IMAGES
of America

COAL CAMPS OF
EASTERN UTAH

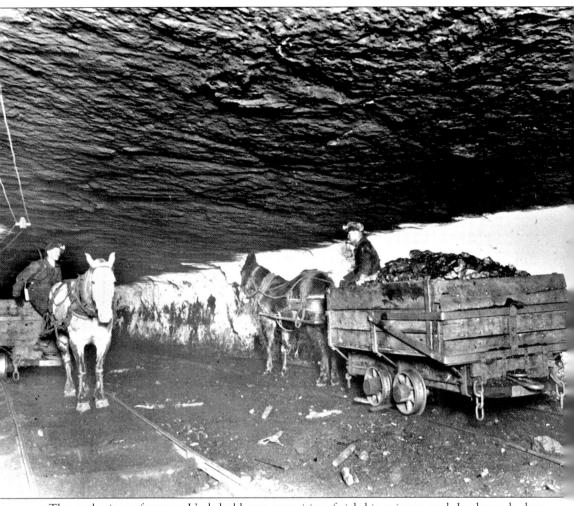

The coal mines of eastern Utah hold vast quantities of rich bituminous coal. In the early days of coal mining, mules were used to haul the coal from underground, and often they spent their entire lives in underground stables. The miners were required to purchase their own mule from the company before they began work like these c. 1930 miners in the Latuda Coal Mine.

ON THE COVER: The coal miners at the Lion Coal Company in Wattis, Utah, paused for a photograph before entering the mine for their shift around 1920. The wooden walkway connected the mine entrance and the mine office. The Wattis Coal Mine was opened near the Carbon/Emery County line in 1916 by William H. Wattis. Wattis merged his company with Lion Coal in 1919 and shipped the coal on the Utah Railway via a spur line that connected the main Utah Railway line with the mine in Wattis. (Courtesy Western Mining and Railroad Museum.)

IMAGES of America
COAL CAMPS OF EASTERN UTAH

SueAnn Martell and the
Western Mining and Railroad Museum

ARCADIA
PUBLISHING

Copyright © 2008 by SueAnn Martell and the Western Mining and Railroad Museum
ISBN 978-0-7385-5645-1

Published by Arcadia Publishing
Charleston, South Carolina

Printed in the United States of America

Library of Congress Catalog Card Number: 2008924287

For all general information contact Arcadia Publishing at:
Telephone 843-853-2070
Fax 843-853-0044
E-mail sales@arcadiapublishing.com
For customer service and orders:
Toll-Free 1-888-313-2665

Visit us on the Internet at www.arcadiapublishing.com

To my grandmothers, Irene Smith Greener and Phyllis Christison Martell, who struggled to make a good life for their families during some difficult times. And to my mother, Maurine Greener Martell, who taught me that everyone and everything has a story.

Contents

Acknowledgments		6
Introduction		7
1.	Finnish Immigrants, Deadly Mines, and Ski Resorts	9
2.	Clustered around the Castle Gate	25
3.	Six Towns in Six Miles	53
4.	In the Shadow of Kenilworth Castle	81
5.	"Dempseyville" and the Wasatch Plateau Trio	91
6.	Coal to Make Steel	99
7.	Lions, Warriors, and Four Mining Magnates	113

Acknowledgments

When I accepted the position of director for the Western Mining and Railroad Museum in Helper, Utah, I had no idea how much I would learn. This education has come in many forms, but my best source of knowledge has been the museum's dedicated volunteers. This group of extraordinary people was born and lived in these wonderful historic areas, and their stories of life in the "good ol' days" have touched my heart. My thanks go out to Dave Baird, Carolyn Birch, Virginia Cochrane, Michael "Moose" Farnworth, Stephanie Giacoletto, Bill Gigolotti, Kathy Hamaker, Malcolm Howard, Larry Hyatt, Councilman P. J. Jensen, Shawna Jensen, Ron Jewkes, Bernice Mascarenas, Betty Mascaro, Charmaine Matthews, Harold "Pudge" Nielsen, Reid Olsen, Sande Riggs, Hollie Sillitoe, Gloria Skerl, Rose Marie Star, and Aldene Thomas. To each one, I am eternally grateful for their support.

I would like to extend a special thank-you to the Museum Advisory Board, under the direction of chairman Pat Kokal and vice chairman Councilman Kirk Mascaro, for the opportunity to use the museum collections in this work. Unless otherwise noted, all of the images were provided by this incredible collection.

My thanks also go out to my fiancé, Darrin Teply, whose constant support and encouragement has kept me going, for his countless hours preparing and scanning each of these outstanding images, and for helping to select these images by paring down 5,000 images to 223 no matter what I said. Darrin's parents, Judith and Jim Teply, have also been a never-ending source of encouragement. Their helpful suggestions and cheerleading have helped me more than I can say.

Last but not least, I would like to thank my family. My parents, the late George and Maurine Martell, and my uncle, Darrell Greener, who taught me how to swim by throwing me in head first, a lesson I've relied on over and over.

INTRODUCTION

By far, eastern Utah's most famous natural resource is its coal reserves. Black diamonds, fossilized sunshine, black gold—no matter how you describe it, coal meant money. The railroad could not exist without it and neither could the towns that were built on it.

The coal beds of eastern Utah follow a semicircular route along the edge of the area known as Castle Valley. The beds are divided into two coal mining regions, the Wasatch Plateau with a length of about 90 miles on the western edge and the Book Cliffs with a length of over 70 miles on the northern and eastern edges. This area encompasses the counties of Carbon and Emery with an additional coalfield known as the Emery in the southern part of Emery County.

The coal mined in eastern Utah is a bituminous coal that was deposited 65 million years ago as plant material. This coal formed in layers much like the separate layers of a cake, with the layers or seams being of varying thickness. The range of the thickness of coal seams in eastern Utah spans between 3 and 30 feet thick. Bituminous coal is a middle-grade coal, much harder than peat but softer than the anthracite coal mined in the eastern United States. While not as clean burning as anthracite, bituminous coal is a high-quality, hot-burning coal.

Coal production in the eastern Utah coalfields began in the 1870s with the initial mines opening in the Scofield area in the northwestern corner of Carbon County. The rich coal deposits caught the attention of railroad owner William Jackson Palmer, who quickly bought the mine and rerouted his railroad to be closer to the deposits. Other mines soon followed suit and began operations anywhere the coal could be mined and transported.

As new mines opened up, the mining companies built towns. These self-contained areas known as coal camps provided the miners and their families with the basic necessities at a price. Before the early 1900s, the mining companies provided the miners with a modestly furnished cottage, sometimes no more than a canvas tent, so long as they continued to work for the company. The miners were paid by the ton of coal removed and were paid in scrip—company-generated tokens that were only good at the company-owned store. Miners were required to buy all of their equipment, including their own dynamite, lanterns, and mules. By 1900, the miners were being paid 60¢ per ton of coal. A pay stub from the Winter Quarters Mine in 1899 showed a miner receiving $61.01 for 30 days of work; however, that same amount was deducted for expenses, leaving the miner and his family with nothing.

While the company controlled all operations of the mining camp, workers fed up with company domination began to talk of forming unions. These discussions led to violent strikes with destroyed property and miners and mine officials killed. Miners and their families were thrown out of their homes and the miners incarcerated based on their ethnicity. Children were born in neighbors' sheds and chicken coops because they had nowhere else to go. Union organizers persuaded mine workers to meet in Helper—neutral territory—to discuss the benefits of unions. These union gatherings were disguised as miners' dances.

Eventually, these strikes led to better working conditions and increased pay for the miners. The miners no longer had to purchase their own equipment and were paid for their time to

travel to and from the working face of the mine, a trip that could take as long as an hour each way in some mines. The miners were no longer paid in scrip, and company stores became general merchandise stores where people could shop voluntarily.

Eastern Utah coal mines are underground mines, with the average coal mine working 1,500 feet below the surface. These deep, underground work areas create hazardous conditions that do not exist in surface mining. Deep mines produce methane gas and coal dust; both are highly explosive when exposed to an open flame. Overburden, the amount of rock above the mined coal seam, can exceed 2,000 feet in these mines, creating conditions ripe for cave-ins and collapse.

With these hazards prevalent these eastern Utah mines, accidents and disasters were common. Two of the deadliest mine disasters in the United States occurred in these coalfields; the 1900 Winter Quarters explosion that killed 200 and the 1924 Castle Gate explosion, which killed 171. These disasters struck at the core of the communities, and people from all over the region felt the pain. Families were left with no husbands or fathers, and the women had to find other ways to earn money. One woman baked and sold 200 loaves of bread a day after her husband was killed in Winter Quarters.

While the coal camps were hard living and disaster was always present, they were also places of joy. Families were raised there, and children played in the nearby creeks, on the mountainsides, and at the local amusement hall. Dolls and sleds were the toys of choice. If money was too tight and a doll could not be purchased at the store, sticks and rocks dressed in leaves did just as well. Schools educated the children, and hospitals and company doctors cared for the sick. The communities were tight-knit, and a fierce sense of community pride came out during baseball games.

The camps were populated by immigrants representing at least 30 different nationalities. Each brought pieces of their country and infused their lifestyles into the unique cultural brew that made up eastern Utah. Although tensions ran high at times between the different ethnic groups, each one soon found their places alongside others in the mines as well as the communities.

Over the years, there have been over 98 coal mines in operation within the confines of Carbon County. Some of these mines have been short-lived operations, while others were large-scale, mechanized productions that eventually incorporated the smaller operations into their own. Some utilized labor from nearby camps; others began their operations after the era of the coal camps had died away, but all served to shape the face of eastern Utah.

Today coal mining is still an important part of the economy of the area. While the number of miners required to work a mine has decreased significantly with the introduction of machinery, the coal mines are still one of the largest employers in the county. At the height of the coal camps, it was common for the mines to employ up to 500 miners to work both the day and night shifts. Now it only takes a handful to keep the mine at its peak production. Coal mining in eastern Utah has made the state 12th in the nation in coal production.

There is a popular slogan in the coalfields of eastern Utah, "When you turn on a light, thank a coal miner." As you thank them, remember that those miners have more than one member of their family who was raised in the coal camps of eastern Utah.

One

Finnish Immigrants, Deadly Mines, and Ski Resorts

Located in the northwest corner of Carbon County, the towns of Winter Quarters, Clear Creek, and Scofield represent the beginnings of coal mining in eastern Utah. The first to be founded, Winter Quarters, made its mark as the site of one of the worst coal mining disasters in U.S. history; a tragic honor it still holds. Winter Quarters started strong, burned hot, and burned out. Founded in 1875 and closed in 1928, Winter Quarters only survived a short 53 years before the town was abandoned.

Four miles south of Winter Quarters, the small logging community of Clear Creek sprang up on the banks of Mud Creek to provide heavy timbers for the Winter Quarters mine. A rich seam of high-quality coal was soon discovered in Clear Creek. The Denver and Rio Grande Western Railroad, owner of the two camps, soon constructed a railroad line into the town, and Clear Creek the mining camp was born. The seam was difficult to work, and by the 1950s, only a small mining operation remained. Undaunted, Clear Creek took advantage of their 8,300-foot elevation and opened a ski resort. That too proved to be short-lived when the winters became short and the snowfall light.

Seen as the hub of Pleasant Valley, the town of Scofield escaped the boom-and-bust cycle so prevalent in eastern Utah. Scofield served as a mercantile and agricultural center for the neighboring towns of Winter Quarters and Clear Creek. Today Scofield remains as a recreation center with water sports, hiking, and hunting taking the place of mining and logging.

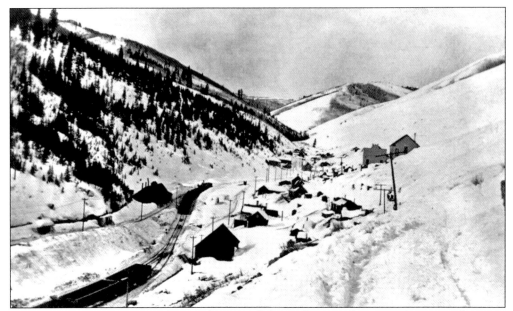

The winter of 1875 saw the first settlement of the aptly named Winter Quarters when two prospectors, John Nelson and Abram Taylor, spent a difficult winter holding a newly discovered coal claim. Located in a narrow canyon, the town site of Winter Quarters shared space with the creek and later the railroad. This c. 1910 photograph shows most of the town. The mine is located near the tree line at the upper center of the photograph.

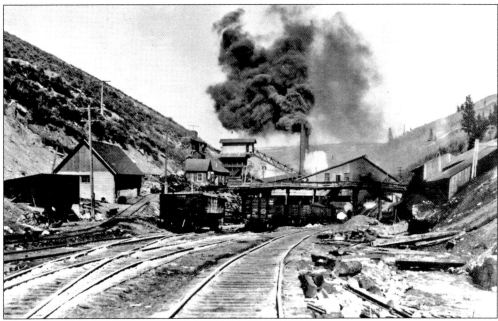

Because of the harsh winters, getting the coal out when it was needed the most was nearly impossible. By 1879, Milan Packard built a narrow-gauge railroad line to service the new camp. Packard paid his workers on the line with cloth instead of cash. The road was dubbed the Calico Road. This photograph shows the Winter Quarters tipple around 1910 and railroad lines after the Denver and Rio Grande Western Railroad had taken over the operation.

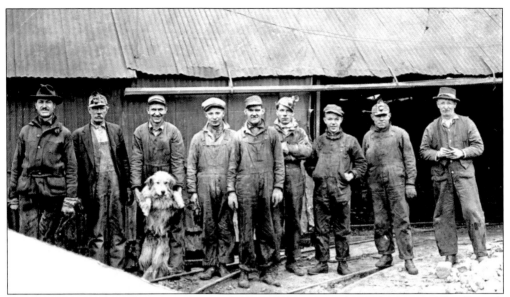

Many of the miners at Winter Quarters were of Finnish and Welsh decent. The Finnish immigrants liked the Pleasant Valley area, as it was similar to the home they had left behind. These miners posed outside one of the aboveground shops at Winter Quarters around 1910.

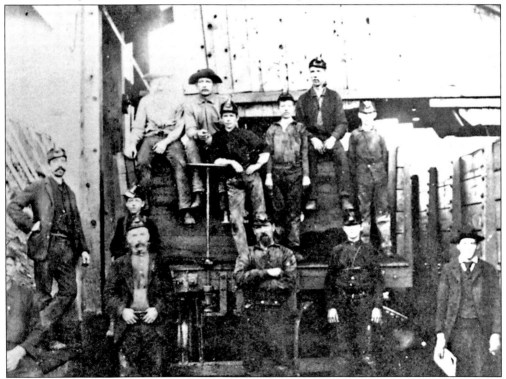

Between the late 1870s and the early 1900s, work in the coal mines was truly a family affair. Men would be employed by the mine company, and they in turn would bring their young sons, some as young as six years old, to help load as much coal as possible. A group of men and young boys posed on a wooden coal car at the tipple in Winter Quarters around 1900.

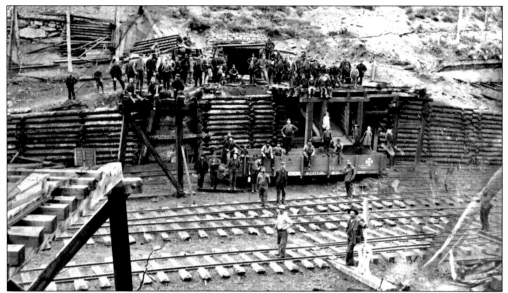

The early coal miners were paid by the amount of coal they removed from the mine and deducted for any rock put into their cars. The miners used their young children to remove rock from the coal. These boys earned the name bony pickers. Because they did not work directly for the coal company, no labor laws were broken. A large group of miners and their sons pose at the entrance to the Winter Quarters mine around 1900.

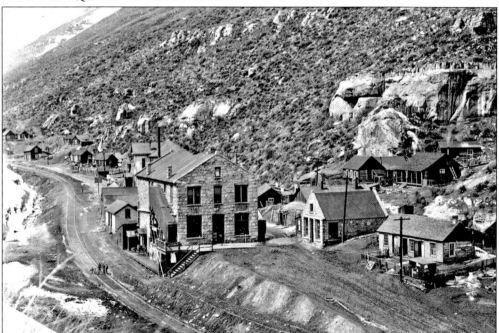

As the coal mines at Winter Quarters began to flourish, so did the town. Like all coal mining towns, Winter Quarters was completely owned by the mine company. The Pleasant Valley Coal Company Store shown in this c. 1900 photograph served as the center of the community. The mine office was located upstairs. Miners were paid in scrip, which was only redeemable at this store.

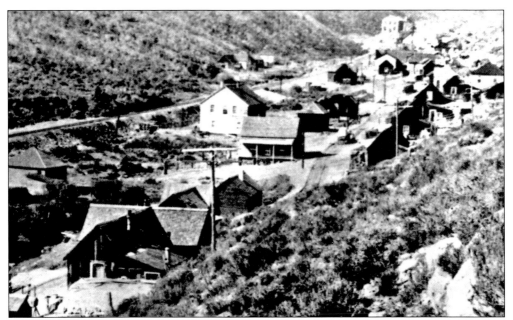

While Scandinavian immigrants made up the largest population at Winter Quarters, other nationalities also found work there. The large white building at the center of the c. 1910 photograph is the Japanese boardinghouse. In an effort to control the workers, mining camps often segregated the population by nationality. Single miners were afforded rooms at a boardinghouse, while married miners were given the use of a modest home. Rent was deducted from their paychecks.

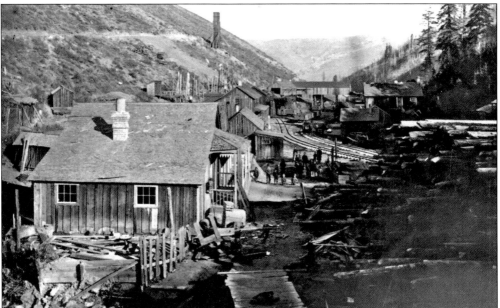

Photographer G. E. Anderson captured this c. 1890 early view of Winter Quarters, looking like a shanty town, and its residents. In an effort to accommodate as many miners as possible, towns were often thrown together with any available materials. The pile of lumber shown at the right suggests other homes and outbuildings were soon on the way.

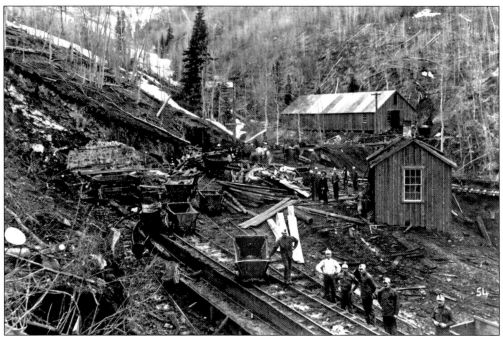

In the morning of May 1, 1900, a powerful explosion rocked the valley. In Winter Quarters and neighboring Scofield, wives and children of the working miners were planning their May Day or Dewey Day celebrations. Soon word spread that the Winter Quarters No. 4 mine had exploded. This photograph shows some of the devastation at the mine entrance. Although the explosion occurred deep underground, the blast blew miners from the entrance across the canyon.

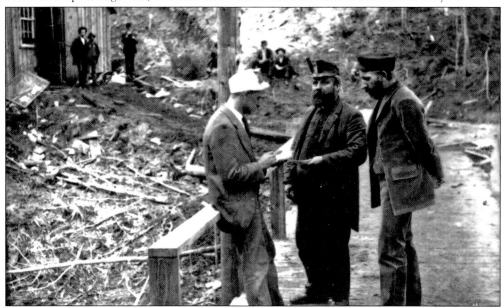

Confused miners ran right into the flames and toxic gas. From left to right are Frank Cameron, superintendent of the Castle Gate Mine; Thomas ("T. J.") Parmley, superintendent of Winter Quarters; and H. B. Williams, superintendent of Clear Creek. Parmley's brother William perished in the explosion.

Almost immediately, aid began to pour into the grief-stricken valley. The final death toll was estimated at 200 men and boys with 15 boys under the age of 15. Families claimed the dead numbered closer to 250. Railroad cars loaded with caskets came from as far away as Denver, Colorado. Here the caskets are being unloaded at the Winter Quarters store.

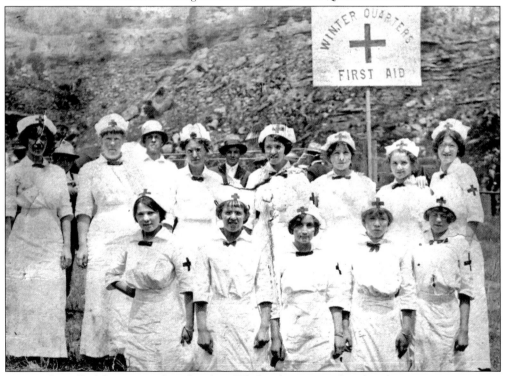

Women lost all of the men in their families. While a few returned to their home countries, many more made the decision to stay. This photograph of the all-female Winter Quarters First Aid team was taken during a c. 1920 competition to hone their skills.

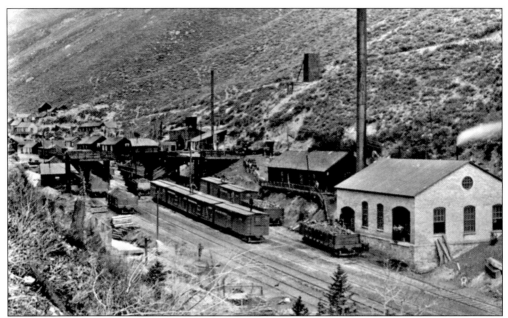

While the disaster rocked the mining communities of eastern Utah, it was soon business as usual. Within two months, the mine had opened with a new crew of miners. For more than two decades, Winter Quarters continued to produce coal and the town thrived. In 1928, the coal market slipped, and Winter Quarters' 53-year presence in the coal industry quietly faded into history. This c. 1910 image shows Winter Quarters in happier times.

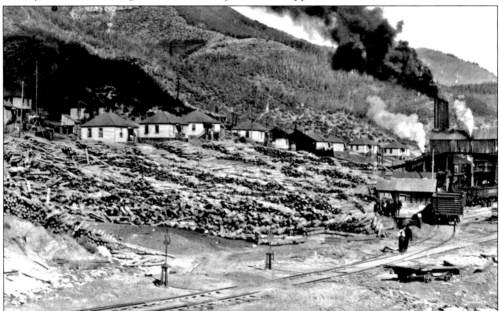

Located south of Winter Quarters, the town of Clear Creek had its beginnings as a logging camp to provide stabilizing timbers for the mine at Winter Quarters. This c. 1900 photograph shows a large pile of heavy timbers ready for use. In August 1899, a new deposit of high-quality coal was discovered in the camp and the Denver and Rio Grande Western Railroad, owners of the Pleasant Valley Coal Company, opened the coal mine.

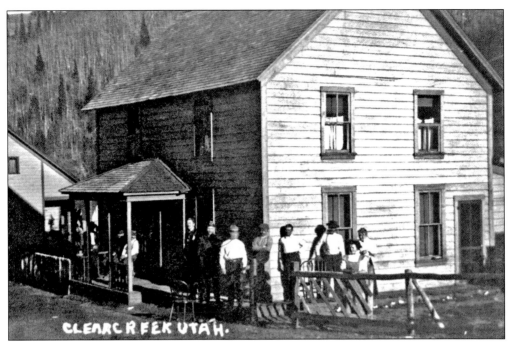

Like Winter Quarters, Clear Creek also had a large Finnish population. This c. 1903 photograph appears to be a boardinghouse in Clear Creek. By the early 1900s, Clear Creek boasted a population of over 450 people, with men working in both the coal mines and the local sawmill. The railroad ran two trains per day into the camp.

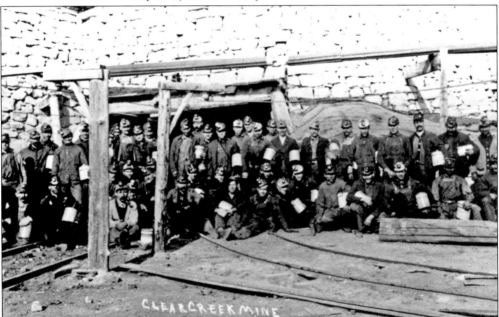

In the early 1910s, the miners at Clear Creek posed for a photograph in front of the entrance to the mine before their shift. The miners are carrying their lunch pails in preparation for their day underground. The miners' lunch pails were a two-part bucket—the smaller portion at the top held their food, while the larger portion at the bottom held fresh water.

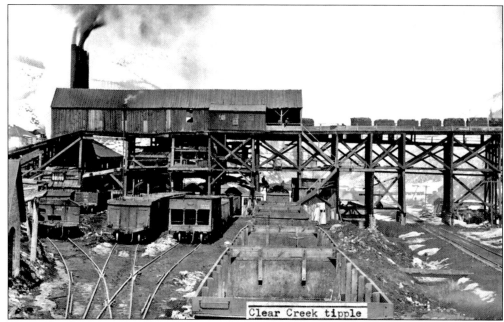

Owned by the Denver and Rio Grande Western Railroad, the Utah Fuel Company effectively shut out the Union Pacific from the Utah coal trade. Shown here is the tipple at Clear Creek with rows of coal cars waiting to be filled in 1910. A coal mine's tipple was a large building where coal was brought from the mine, sorted, and then deposited into railroad cars by the size of the coal.

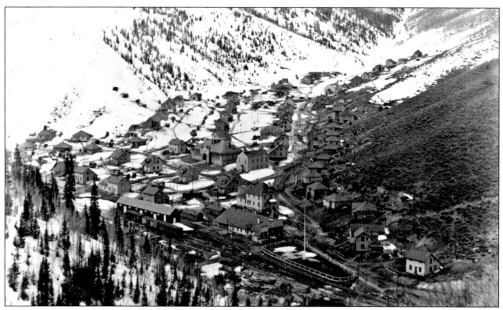

At its peak population during the early 1920s, the town of Clear Creek housed nearly 600 residents. This photograph from the late 1910s shows the mine office and company store (front center next to the small park), the two-story hospital to the side, and the large brick school with the arched doorway (left center). Today a handful of residents still live there year-round, while the other homes are used as summer cabins.

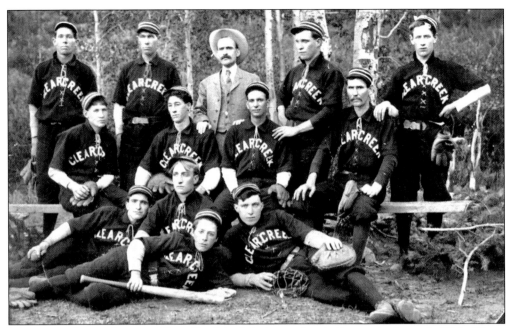

Like most other coal camps, Clear Creek had their own baseball team in the early 1910s. These teams played each other for community pride and recreation. Men became very good at the game, and these amateur teams often produced some world-class baseball players. Baseball games were grand affairs with spectators dressing in their Sunday best and picnicking on the field after the game.

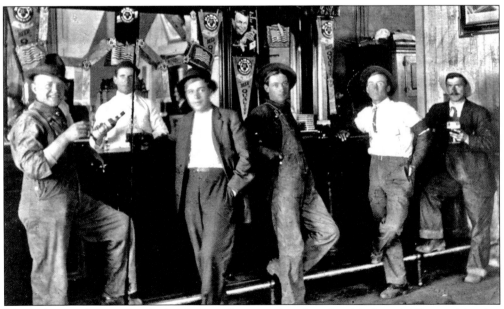

Miners frequently turned to the local saloon for recreation after a hard day's work. The combination of single men and some disposable income meant that the saloons and amusement halls were always busy. This saloon in Clear Creek was operated by Frank Frageskakis, a Greek immigrant. Here Frageskakis pours a drink for five unidentified coal miners and railroad workers in 1912.

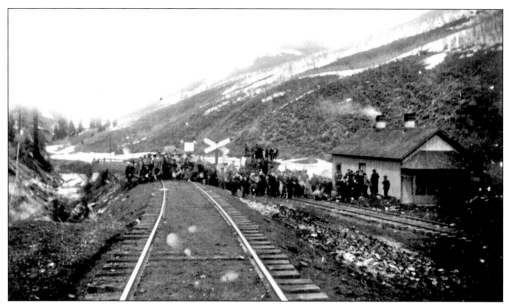

Labor strikes were ever present in the coalfields. Difficult working conditions, low pay, and accusations of company corruption were constantly fueling the fires. One of the largest strikes took place in 1922. Here a group of striking miners blocked the railroad tracks into Clear Creek. Strikes like these were often violent, and many miners were blacklisted and thrown out of their company-owned homes based on their ethnicity.

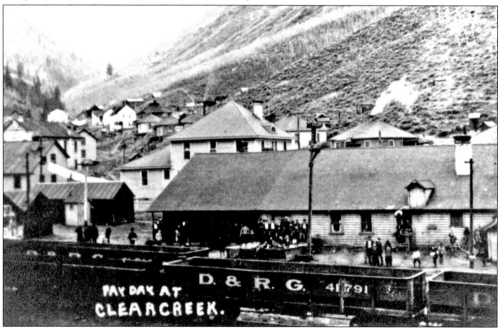

Payday was a happy day in the mining camps. In order to prevent theft, payday was never the same day each month and was only announced once the payroll had safely arrived in the hands of the paymaster. This photograph from 1903 shows groups of miners assembled at the mine office in Clear Creek at the rear of the company store. The company hospital is visible just behind the mine office.

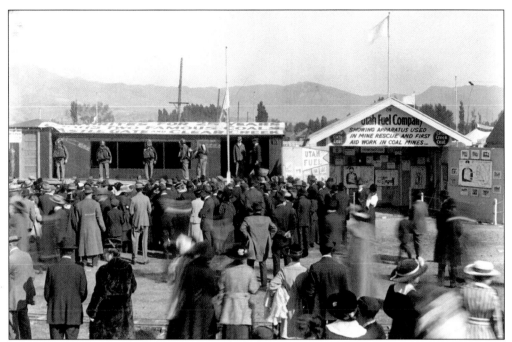

After the Winter Quarters Mine Disaster in 1900, public focus was on mine safety. People gathered at a fair in the Provo, Utah, area to see the latest in safety gear. The signs read "Favorites for 25 Years Utah's Two Famous Coals Castle Gate and Clear Creek" and "Utah Fuel Company Showing Apparatus Used in Mine Rescue and First Aid Work in Coal Mines." The otherworldly appearance of the rescue workers created quite a stir.

By the 1930s, the coal seam at Clear Creek began to dip deeper into the mountain and removing the coal became more difficult. By the 1950s, it looked as if the town was doomed. However, Clear Creek was not going to die that easily. The town developed a small ski resort that was extremely popular with the Carbon County population, but sparse snowfall closed the resort for good just a few years after it opened.

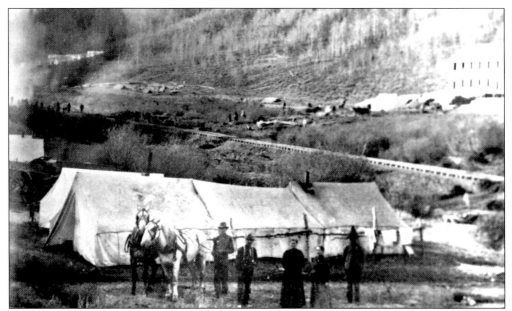

Although technically not a coal camp, Scofield did have its place in the coal mining history of eastern Utah. The small coal mining operations of the Blue Seal, the Kinney, the Jones, the Columbine, and the Union Pacific Mines were undertaken just outside of the town. This photograph from 1883 shows railroad workers just outside of Scofield as they worked to complete the Pleasant Valley branch of the Denver and Rio Grande Western Railroad (D&RGW).

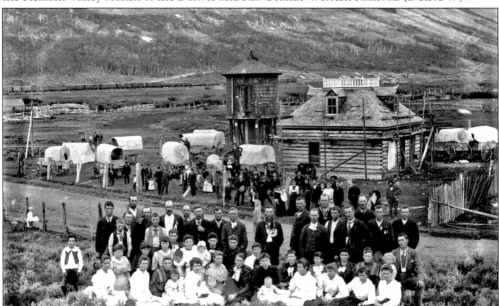

With a large Welsh population in the Winter Quarters, Clear Creek, and Scofield area, their home country traditions were extremely important. Welsh musician and coal miner Thomas L. Hardee organized the Castle Valley Choir to compete in an "eisteddfod," an annual festival with competitions among musicians and poets. The members of the choir arrived in Scofield in covered wagons and won the competition over the Scofield Welsh Choir. Thomas L. Hardee is the man in the center of the photograph with the necklaces.

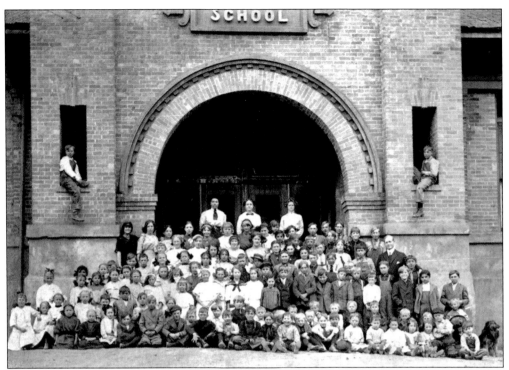

Although they worked in other mines, many coal miners purchased or rented a home in Scofield. As coal mining was a cyclical industry with most coal being mined during the winter months, living in Scofield was beneficial to many miners as they could farm during the summer. Each town in the area had their own schools. This c. 1905 photograph shows the large number of students attending the school in Scofield.

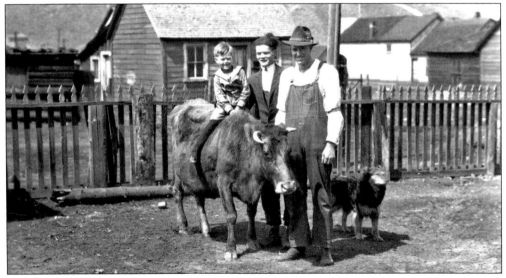

The lush, high mountain valley of Pleasant Valley afforded the miners some success with livestock. Many miners kept livestock for their own use; some used the livestock to make sausage and dairy products that would be sold to others. This c. 1900 photograph shows a Scofield coal miner and his family with their cow.

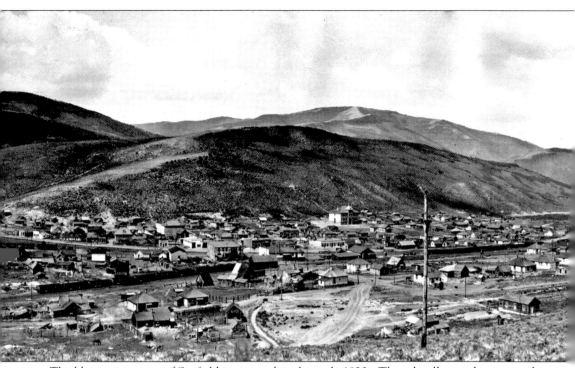

The blossoming town of Scofield is pictured in the early 1920s. The schoolhouse dominates the photograph (right center), and the road leading to Winter Quarters curves up and to the left. The D&RGW Pleasant Valley branch is seen in the foreground, while the spur into Winter Quarters canyon can be seen at the far left. The photograph was taken near the site of the Scofield Cemetery, resting place of many of the miners killed in the Winter Quarters Mine disaster. Today Scofield still maintains many year-round residents. The nearby Scofield Reservoir provides drinking and irrigation water for most of Carbon County, and it boasts world-class fishing and ice fishing for the sportsman. Hundreds of summer homes and cabins line the shoreline of the reservoir.

Two
Clustered around the Castle Gate

Centered just north of Helper, the coal mining area of Castle Gate produced some of the best coal in Utah. This, combined with the striking scenery of the sheer rock cliffs that made up the formation known as the Castle Gate, drew thousands of immigrants who poured into the state looking for work.

The largest of the towns in the area was Castle Gate itself. Founded in 1883 by the Denver and Rio Grande Western Railroad, Castle Gate survived as a large town until 1974 but survived as a mining area much longer. It was not until 2000 that the last coal mine, the Willow Creek Mine, was sealed and mining operations halted. Castle Gate boasted a hospital, school, amusement hall, and two churches, as well as its own baseball field.

The camps of Royal and Heiner sprang up around Castle Gate to take advantage of the thick bituminous coal. Unlike other coal camps that were named for geographic features, Royal and Heiner were named after the mining companies. The names of these types of camps changed frequently.

These camps were some of the most visible of those in eastern Utah. Located in Price Canyon, a major north-south transportation corridor, these camps showcased Utah's coal industry, and great piles of coal showed people that their energy needs were met at the Castle Gate.

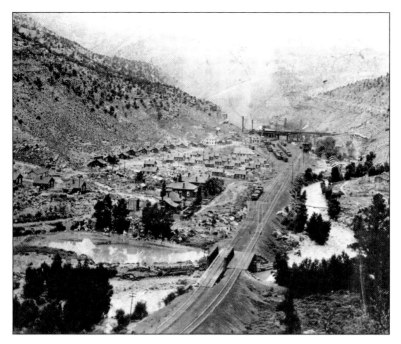

Founded in 1888 as a mining venture of the Denver and Rio Grande Western Railroad, the Castle Gate coal mine and the associated coal camp soon became a major coal mining center. The camp grew to boast its own hospital, school, and amusement hall. This c. 1908 photograph shows the northern end of town with the large wooden coal tipple at the center.

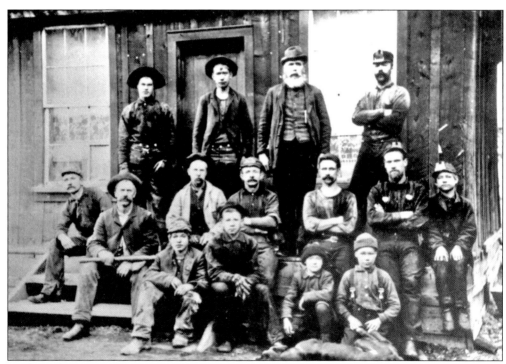

In the early 1900s, men earned 60¢ for every ton of coal removed from the mine. While their fathers dynamited the coal from the face of the seam, boys as young as six years old loaded it in the coal cars, carefully removing any rock. Any rock in the car would cause a deduction in wage. Here a group of miners and their sons stand on the front steps of a tar-paper shack in Castle Gate around 1890.

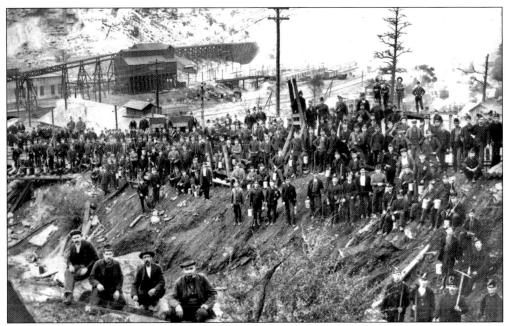

Originally incorporated as the Pleasant Valley Coal Company, Castle Gate was the sister mine to the Winter Quarters Mine in northwest Carbon County. The Denver and Rio Grande Western Railroad actively recruited labor from Europe to work in the mine. So many Italian immigrants flooded the Castle Gate mine looking for work that the mine was soon dubbed the "Italian Mine." This mine crew posed for a photograph before entering the mine around 1900.

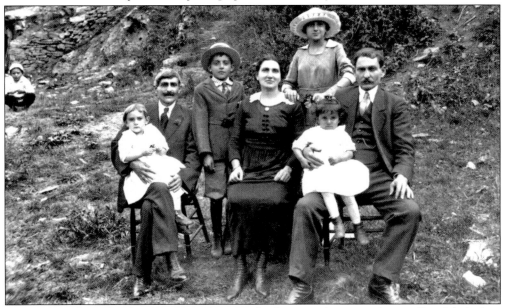

The Italians brought their unique culture with them to their new home. Bread baked in outdoor ovens and homemade wine were commonplace in the Italian parts of the coal camp. The mining company segregated the ethnic groups in an effort to keep talks of strikes at bay. Here an Italian family in their Sunday finest posed for a photograph on a c. 1916 family picnic near Castle Gate.

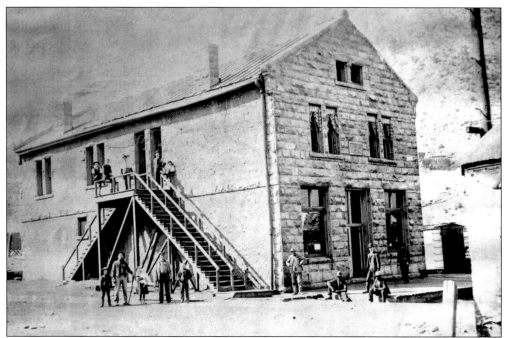

On April 21, 1897, Butch Cassidy and his partner Elza Lay robbed the Pleasant Valley Coal Company payroll of nearly $8,000 in gold. The daring daylight holdup took place at the mine office, shown here. Butch and Elza relieved paymaster E. L. Carpenter of the gold at the base of the steps leading to the office while 150 stunned coal miners looked on. This c. 1898 photograph shows a mine company lawman (second from left). (Courtesy SueAnn Martell.)

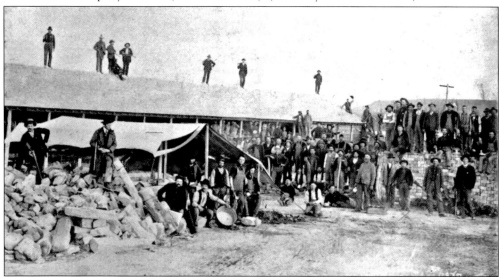

This photograph is often mistaken as the aftermath of the Pleasant Valley Coal Company payroll robbery. In reality, it was taken in 1903 during a coal mine strike. All Italian coal miners were rounded up and incarcerated in Price, Utah, under the accusation of union organization. Though the photograph has nothing to do with the robbery, a member of the Wild Bunch, C. L. "Gunplay" Maxwell (far left, first row), acted as a deputized guard during the strike. (Courtesy SueAnn Martell.)

This c. 1900 image shows the southern end of Castle Gate where it joins with Willow Creek to the east. The collection of buildings in the foreground of the photograph shows a saloon with the proprietor's home at the back of the establishment and a boardinghouse (far right) next door. This area of Castle Gate is now the location of the coal-fired electric-generating carbon plant owned by Rocky Mountain Power. (Courtesy SueAnn Martell.)

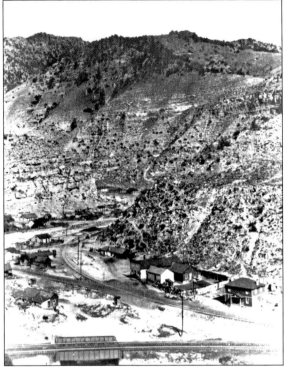

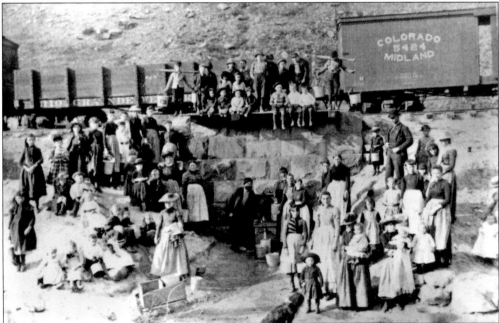

In the late 1890s, the residents of Castle Gate obtained their water from a trip to the spring. This image shows dozens of families waiting their turn for water from the spigot. Each family brought their buckets and some unique ways to carry the water back to their homes. The spring was located near the railroad tracks where a Rio Grande Western flat car and a Colorado Midland boxcar stand.

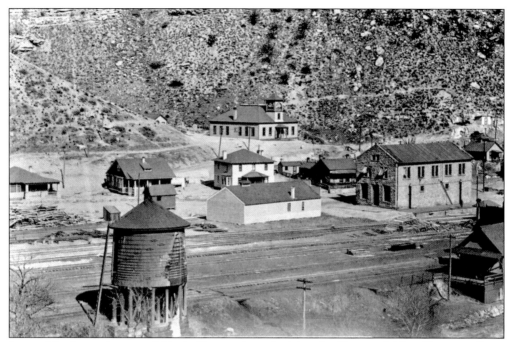

Located in the main part of Castle Gate and overlooking the Pleasant Valley Company Store and Mine Office, the school (upper center) at Castle Gate was brand-new when this photograph was taken around 1916. The school was used for grades one through nine, with the children traveling to Price 10 miles south for high school. The tracks of the Denver and Rio Grande Western Railroad run in the foreground past the water tower.

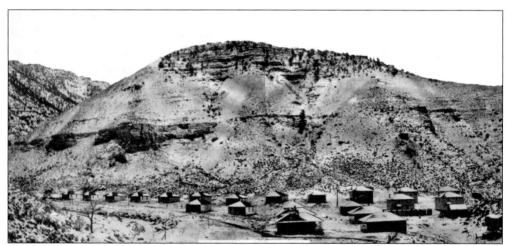

Still a part of Castle Gate, the area known as Willow Creek was located in a side canyon to the east of Castle Gate. Named for the creek that flows through the canyon, Willow Creek was the site of the Castle Gate No. 2 coal mine. Shown here around 1915 are the neat rows of company houses, called salt-box houses because their shape resembles that of an old-fashioned salt box.

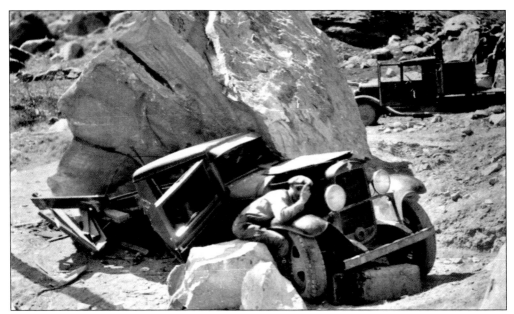

By the mid-1910s, the Midland Trail had made its way through Castle Gate via Price Canyon. To drive on this road through the area was not a task for the faint of heart. The road, barely wide enough for one automobile and with hairpin turns, terrified the new drivers. This photograph taken in the early 1920s shows another hazard of the road: rock falls. Amazingly, the driver of this truck escaped unharmed.

The town of Castle Gate derives its name from this rock formation located at the north end of town. The two rock formations appeared to open and close as travelers passed through them. This c. 1950 photograph shows the modern road through the gate before the right side of the formation was demolished by road crews seeking to widen the road. Today only the left side remains unchanged.

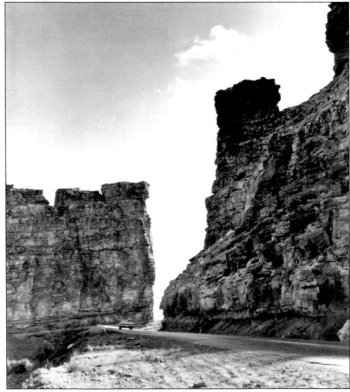

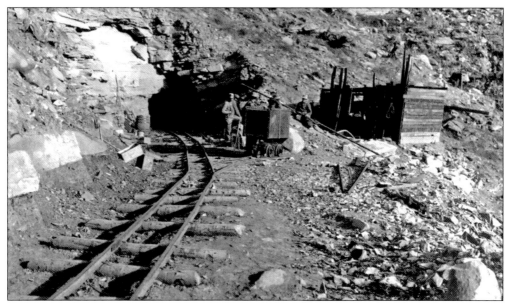

This c. 1911 photograph shows the construction of the long rock tunnel to connect the Castle Gate tipple with the newly opened Castle Gate No. 2 Mine in Willow Creek. The temporary shack near the right of the tunnel portal is the construction blacksmith shop. The rails are temporary mine rails laid down to aid in the construction of the tunnel. (Courtesy SueAnn Martell.)

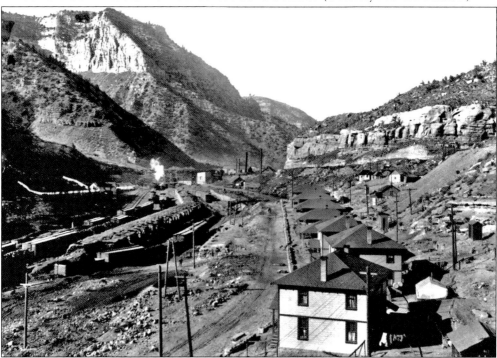

The mine company built a battery of coke ovens, pictured left center in this c. 1905 photograph. This area of the camp was known as Coke Oven Row. The ovens at Castle Gate were eventually torn down, as a better grade of coking coal was discovered at Sunnyside in the eastern part of Carbon County. (Courtesy SueAnn Martell.)

The Mangone family immigrated to Castle Gate from Italy in the early 1910s. Frank and his new bride, Teresa, had the blessing of Teresa's parents on the condition that Frank could prove he could provide for Teresa in their new home. In order to get their full blessing, Frank hired a photographer to record a very important event, Frank's first payday. The photograph on the right was taken on November 10, 1913, and shows Frank handing over his pay to Teresa, proving once and for all to Teresa's parents back home in Italy that he could provide for his new bride. The c. 1920 photograph below shows the couple's three children—Benjamin, Leah, and Gabriel—on the front porch of their home in Castle Gate with the American and Italian flags.

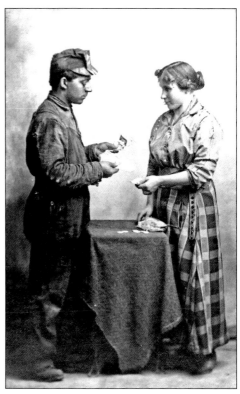

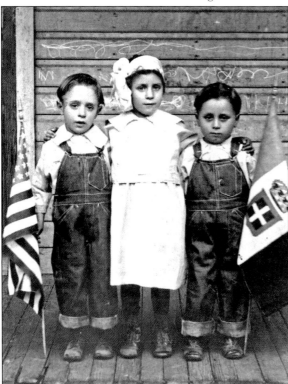

Although modest and sparsely furnished, coal camp housing at Castle Gate was comfortable. Miners and their families worked hard to make the company houses their homes. Outdoor gardens were common, especially among the Italian and Greek immigrants. This image, taken around 1900, shows a typical Castle Gate family proudly showing off one of their few personal possessions, a beautiful rocking chair.

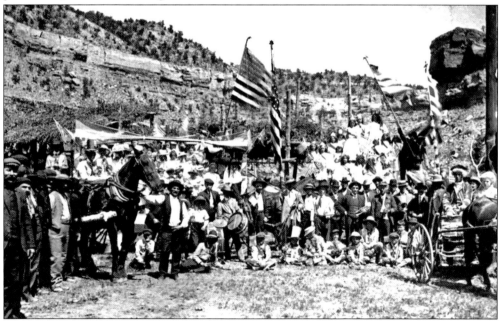

Life in the coal camps was not always just about work. Special events and celebrations were held frequently to ease the difficulties of life underground. This c. 1910 photograph shows a Fourth of July celebration in Castle Gate. The event was complete with bands, crowned beauty queens, and even a look-alike couple of George and Martha Washington (far right). The newly arrived immigrants to the area were proud and excited to celebrate their new country's birthday.

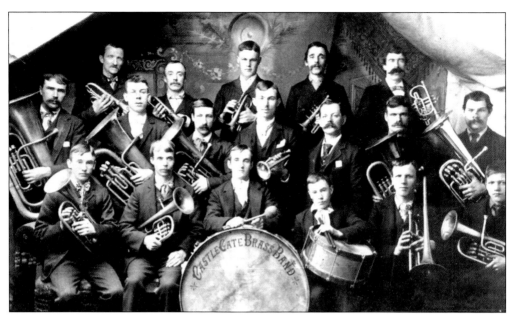

Castle Gate had its own brass band under the direction of Glen D. Reese and R. R. Kirkpatrick, president. The 22-piece band posed with 18 of their members for this photograph on September 15, 1916. Members of the band included Riley Huff, trombone; Frank Parriette, Howard Perkins, John Hamal, Harold James, and Alfred Reese, cornet; Theo Reese and Lester Smuin, bass; and Edward Edwards, John Mastrovetis, George C. Littlejohn, and Alfred Mills, altos. The other members are unidentified.

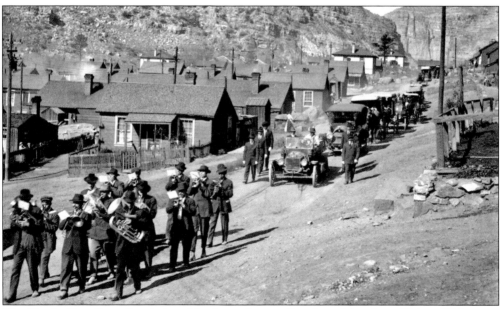

The Castle Gate Brass Band played for funerals as well as for celebrations. This c. 1915 image shows a funeral procession slowly leaving the northern end of Castle Gate for the long walk to the cemetery located in Willow Creek. The six pallbearers walked to the sides of the lead car while the mourners followed in cars and horse-drawn carriages. Many of the residents came from their homes to pay their respects to the deceased.

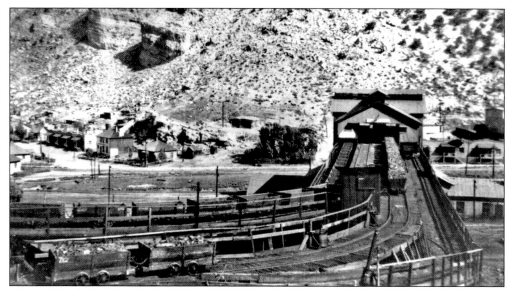

The tipple of a coal mine was the heart of the mining operations once the coal left the mine. The tipple was the building where the loaded coal cars from the mine were unloaded. The coal was then sorted and dropped into the waiting railcars below for transport. This c. 1900 photograph shows the tipple of the Castle Gate No. 1 Mine stretching over the railroad tracks next to Main Street.

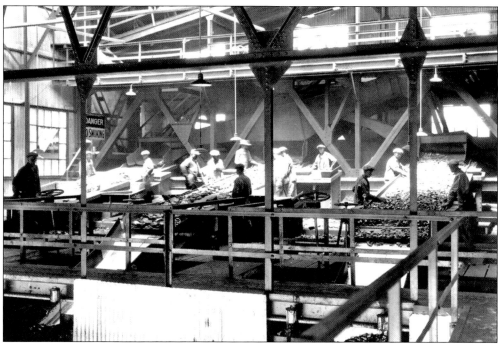

Inside the tipple was a hive of activity. This image shows men working at the picking tables. This is where coal was sorted according to size, and it was also here that boney (coal with rock attached) was discarded. This photograph was taken around 1925. Before 1924, smoking was permitted in the tipple as well as in the mine. Many tipples were destroyed by fire before the explosive nature of coal dust was discovered.

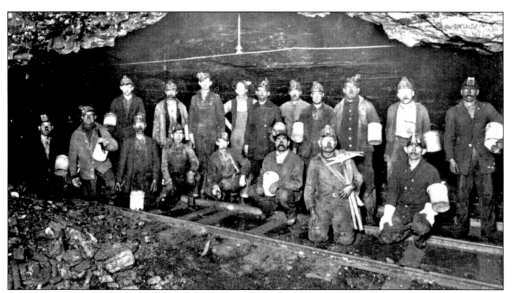

The amount of coal dust on the faces of these miners indicates that the image was taken at the end of a shift. This c. 1910 underground photograph shows the miners inside the Castle Gate No. 1 Mine. The miners are wearing carbide lamps, a precursor to more modern battery-operated lamps. The carbide, placed in the lamp and ignited, burned with an open flame to provide light.

The rich coal deposits of the Castle Gate No. 2 Mine became legendary. This c. 1920 photograph shows the extreme thickness of the coal seam in the mine. At this point, the top of the seam measures an incredible 22 feet thick. At other places in this seam, the coal reached upward of 30 feet thick. Miners called this type of seam "high coal."

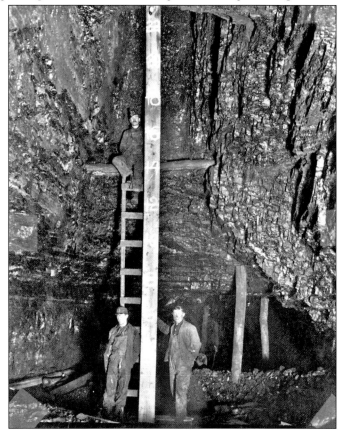

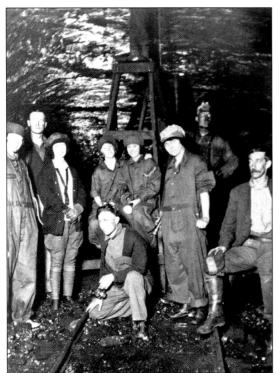

A scene like this one underground in the Castle Gate No. 2 Mine in 1920 was extremely rare. Miners were very leery of women in the coal mine. It was believed that a woman underground was unlucky and would bring disaster to the mine. While the women on this tour seem to be enjoying the novelty of being in a man's world, the men are looking a little nervous.

This eerie photograph was taken inside the Castle Gate No. 2 Mine bathhouse at the mine entrance around 1924. The miners would remove their street clothes and put on their mine clothes before entering the mine at the start of their shift. Their street clothes were raised up on ropes to keep them out of the way and clean until the end of the shift.

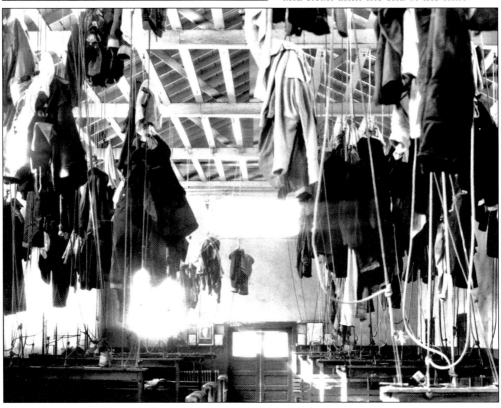

Unlike many of the neighboring coal camps, Castle Gate had its own hospital. This was a company-run affair, and the miners were charged a nominal fee, deducted from their monthly pay, to use its services. While most of the cases seen at the hospital were mild injuries, others were more severe. Accidents occurred monthly and oftentimes resulted in death. This photograph was taken around 1920.

An important part of any mining camp, the company ambulance struck fear into the heart of every woman in town. They knew that if the ambulance sped toward the mine, a loved one was coming out injured or dead. This ambulance proved itself inadequate on March 8, 1924, when the Castle Gate No. 2 Mine exploded, killing 170 men who had just entered the mine for the beginning of their shift. (Courtesy SueAnn Martell.)

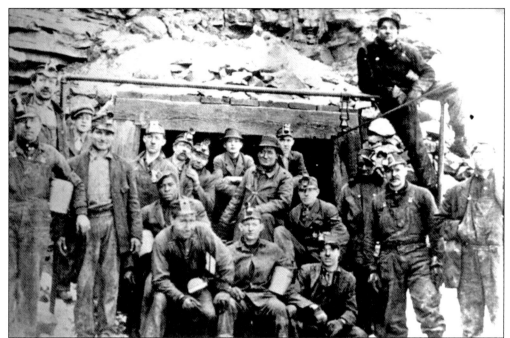

On the morning of March 8, 1924, a crew of 170 miners entered the Castle Gate No. 2 Mine for the last time. Shortly after the start of the shift, an open flame ignited coal dust and methane gas in the air and an explosion tore through the entire mine. This photograph was taken earlier in the year. While their names are not known, it is believed that all of these miners died in the explosion.

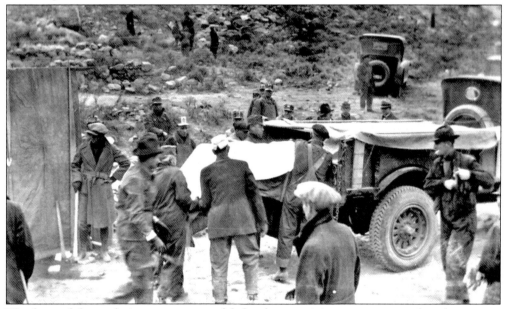

The force of the explosion was so powerful that heavy mining equipment and coal cars were blown from the entrance of the mine, were twisted and misshapen, and came to rest across the creek. Here miners look on helplessly as a body is removed from the mine. Scores of people from neighboring towns traveled to Castle Gate to render aid and to offer support.

Rescue workers and officials were called in from other mining companies, including Winter Quarters and Sunnyside. After years of training, the rescue workers were ill prepared for what they found inside. A young rescue worker became panicked in the pitch-dark mine and removed his oxygen apparatus, similar to the one pictured here. He died almost instantly when the afterdamp (methane- and carbon dioxide–rich air that remains in the mine after an explosion) reached his lungs. His death brought the total killed to 171. As the bodies were removed from the mine, families made funeral arrangements. The last miner recovered from the mine, Basil Gittins, was an immigrant from the United Kingdom whose son Brindley was also killed in the explosion. Here caskets are being prepared on the back of a transport truck outside of the mine office. (Courtesy SueAnn Martell.)

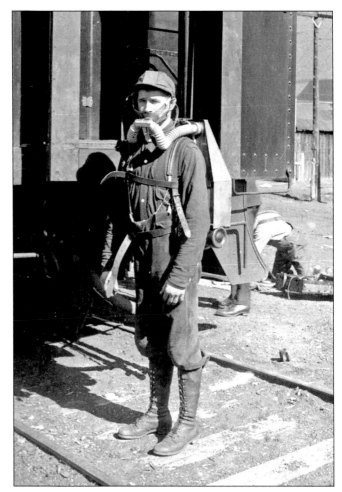

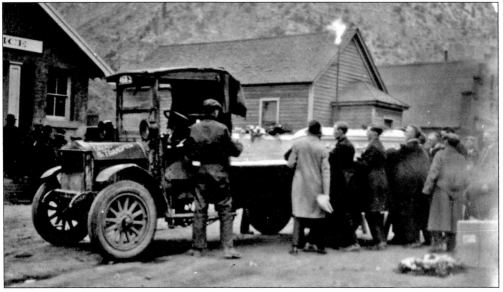

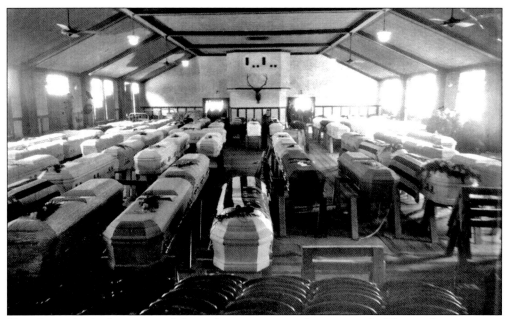

Identifying the bodies removed from the mine was a daunting task. The explosion was so powerful that the check-in board at the nearby bathhouse was thrown from the wall, making it nearly impossible to tell who had been in the mine at the time of the tragedy. The miners were terribly burned, and it was up to their next of kin to identify their loved ones. The Castle Gate Amusement Hall became a makeshift mortuary with row after row of caskets lined up awaiting funerals. While some of the dead were buried in other locations, the Castle Gate Cemetery became the final resting place for many of the victims. Ironically, the cemetery lies directly over the section of the coal mine where the explosion occurred. The photograph below shows a mass funeral at the cemetery. The bathhouse (upper center) and the Castle Gate No. 2 Mine entrance (upper right) are visible.

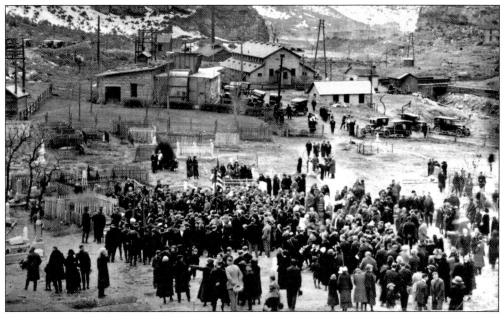

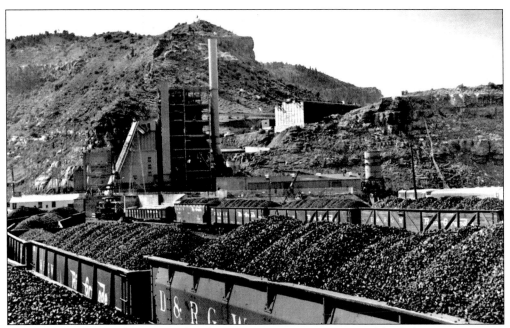

In the mid-1950s, Utah Power and Light began construction on a coal-fired electric generating plant. The carbon plant was located on the southern end of Castle Gate at the junction of Willow Creek and Price Canyon. This photograph, taken in 1954, shows the plant under construction and the thousands of tons of coal waiting to be converted into power.

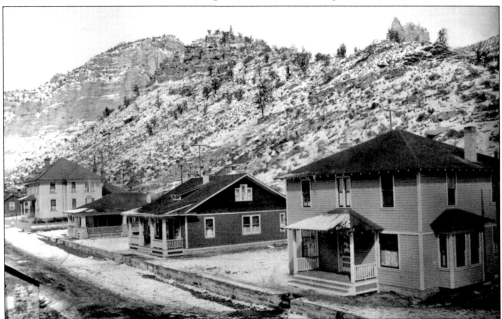

In the early 1970s, Price River Coal decided to close the town of Castle Gate. The residents were given a choice: take the fair market value for their home, or the company would pay to move the home to another location. In 1974, a caravan of homes was moved into the Castle Gate subdivision west of Helper, the company store was demolished, and Castle Gate slipped into memory. Here are some of the homes around 1930.

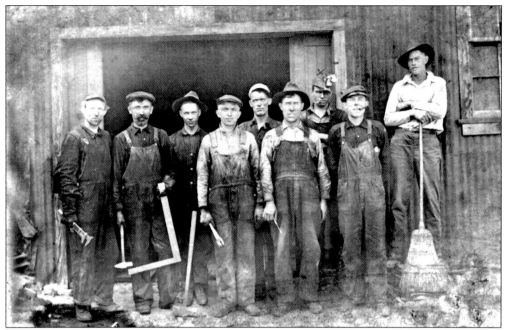

Many of the mining camps of eastern Utah were named after the mine owner. One such camp was Cameron. Located north of Castle Gate in Bear Canyon, Cameron began its life named for mine owner Frank Cameron. This c. 1920 photograph shows the miners preparing for work at the Cameron Mine. When Cameron opened in 1913, it had a workforce of 35 miners.

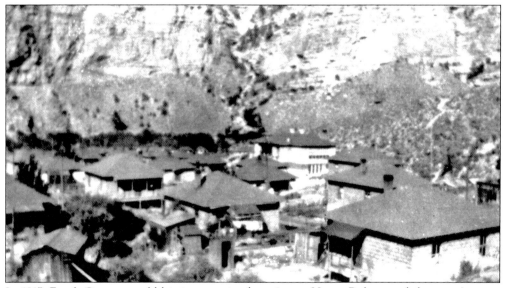

In 1917, Frank Cameron sold his interests in the mine to Henry Rolapp and the town's name was changed to Rolapp. As the town began to grow, it stretched out of Bear Canyon at the mine entrance and moved toward the base of the Castle Gate, shown here around 1918 in a rare photograph.

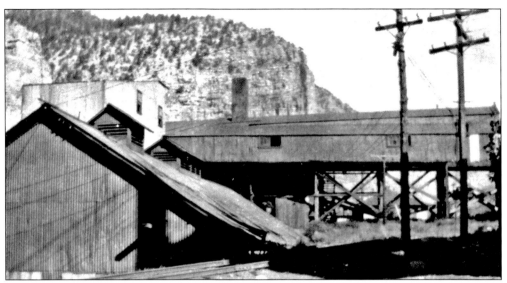

In operation from 1912 to 1962, the mines in Bear Canyon produced nearly 7.4 million tons of coal. The coal seam in this mine averaged 8 feet; it is estimated that nearly 44 percent of the coal was removed from that mine. This c. 1932 image shows the tipple as it stretched over the newly completed highway at the base of the Castle Gate.

In the mid-1920s, the Royal Coal Company purchased the property and the town's name changed yet again, this time to Royal. Royal's population had reached its peak before 1940 with approximately 500 residents. This image shows one of the small but comfortable company homes at Royal around 1974 before the homes were destroyed.

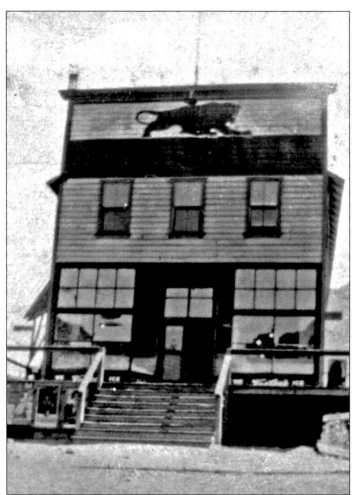

The neat and tidy camp of Royal had no amusement hall, so the local gathering place was the company store (left). The wooden store had an Old West look to it, and its large lion on the front made the store distinctive from any other store in the coal camps.

The large schoolhouse at Royal (below) held classes for grades one through nine while the high school students were bused to Price. In 1918, the out-of-town students were housed in a dormitory where the students paid $4 per week for their room and board. This photograph shows the school including the bridge across the creek in Royal around 1920.

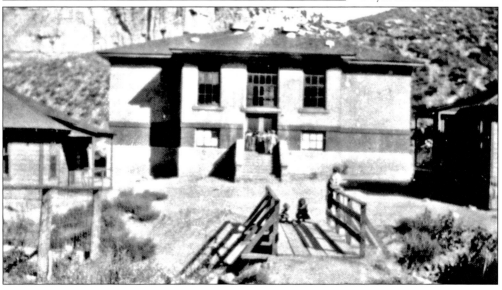

In 1923, Clem Christensen (back row, far right) was the fifth-grade teacher at the Rolapp school. The class consisted of 22 students. Included are Julius Showers, Rex Marsh, Paul Jones, Dora Henderson, Jessie Jones, Laura Grow, Hilda Jones, and Mr. Christensen's daughter. The rest are unidentified.

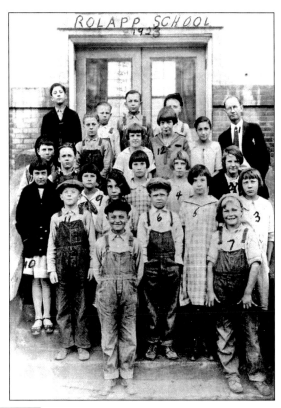

Although not allowed to do so, two boys posed for a photograph on the coal car along the tramway above Royal around 1929. Boys from the camp would sneak up and try to catch a ride on the speeding coal cars as they headed down the steep grade to the Royal tipple. In the background, the east half of the Castle Gate provides a striking backdrop.

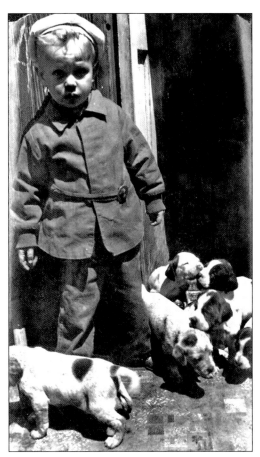

Three-year-old Jimmy Cochrane showed off his new puppies in 1944 outside of the Cochrane home in Royal. The Cochrane home boasted several rooms, wallpaper, and an indoor bathroom—the mark of a thoroughly modern coal camp. Jimmy was the grandson of Walter Cochrane, Royal Coal Mine official, and the son of James Cochrane, a mechanic at the coal mine.

In 1920, the day shift at the Royal Mine stopped for a photograph before entering the mine portal for work. The portal was constructed of local sandstone, hand carved by area Italian stonemasons. The buildings to the left include the bathhouse and the lamp shack.

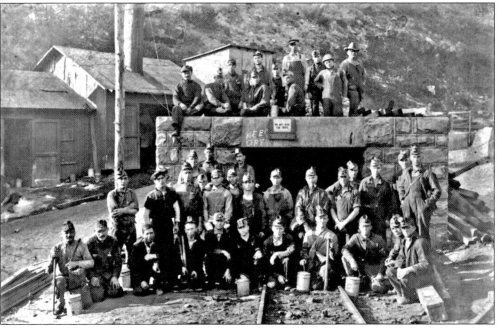

Located just south of Castle Gate, the town of Heiner also faced some name changes. Mine founder Frank Cameron named the town Panther for its location in Panther Canyon. Cameron founded Panther in 1912. The company was reorganized into the Castle Gate Coal Company owned by the U.S. Smelting, Refining, and Mining Company in 1913. This photograph shows the steep tramway leading to the mine in Panther Canyon.

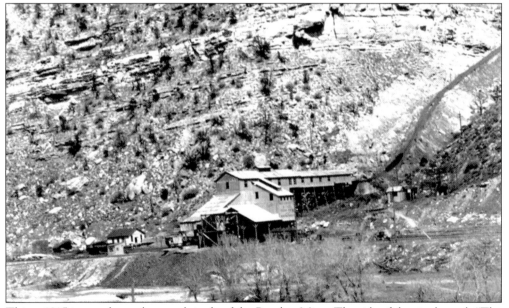

This c. 1915 image shows the metal tipple of the Panther Mine. The side of the tipple reads "The United States Fuel Company" with advertisements for other U.S. Fuel Company mines along the side. A series of coal cars making their way down the tramway (middle right) can be seen heading for the tipple.

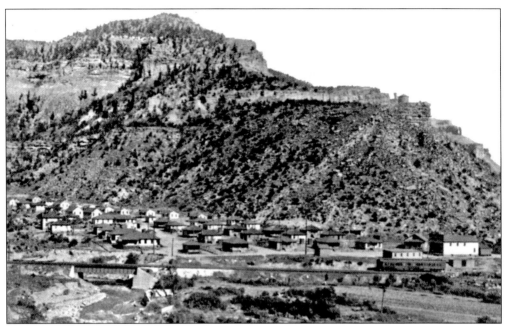

By 1914, Panther's name was changed once again to Heiner in honor of U.S. Fuel Company vice president Moroni Heiner. In the early 1920s, Heiner reached its highest population peak of nearly 600 residents. This c. 1920 photograph shows the main section of town with the Denver and Rio Grande Western Railroad main line running over the Price River in the foreground.

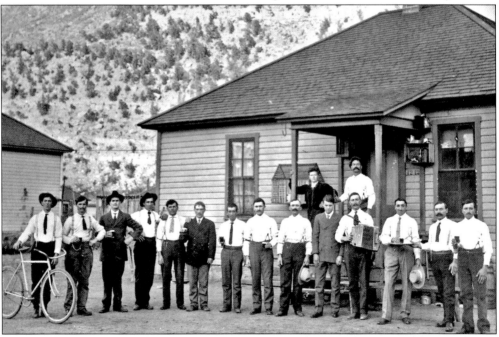

After work, miners gathered together in Heiner to enjoy homemade wine and beer and some accordion music and to show off a new bicycle. Like most of the coal mining camps in eastern Utah, Heiner had a large immigrant population, with the majority of people coming from Italy, Greece, and Yugoslavia. This image was taken around 1920.

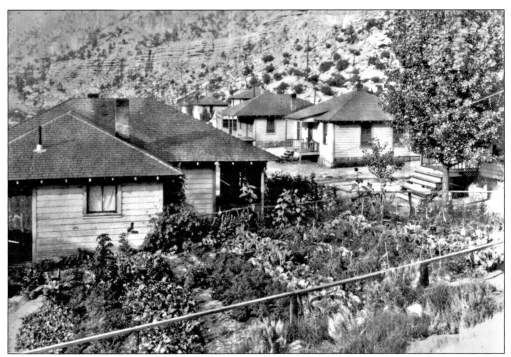

Although the houses in Heiner were owned by the mining company and small by today's standards, the residents did everything they could to make them their homes. With the large ethnic population, many residents grew large gardens just like they had in their home countries. These beautiful, well-tended areas gave Heiner a wonderful, homey feel. This is Martin Perrero's garden, which won first place in the 1929 Heiner landscape competition.

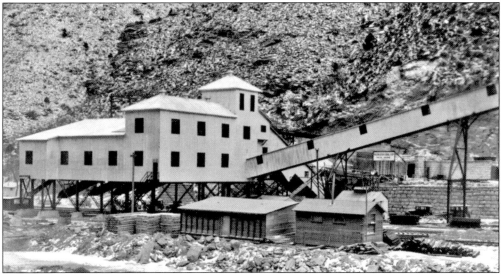

Northwest of Royal, the New Peerless Coal Mine was opened in 1930. However, the coal seam was more than two miles below the portal of the mine, making mining difficult. On March 8, 1930, six years after the Castle Gate tragedy, the mine exploded, killing Lester E. Curtis, William Curtis, James Jensen, Clement Turner, and William Daniel Turner. By 1931, in the midst of the Great Depression and facing several mining challenges, the mine closed.

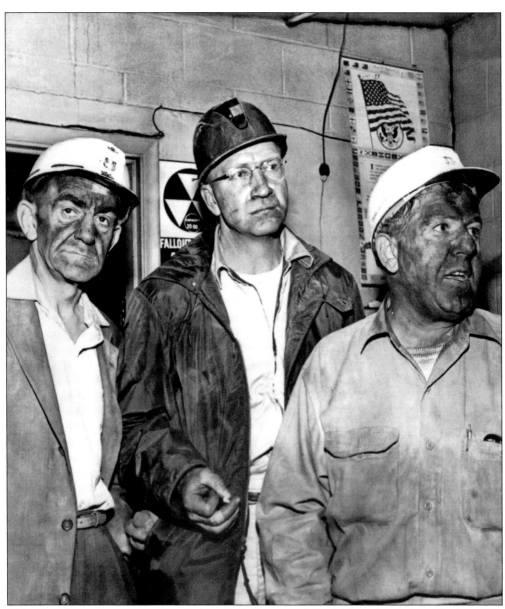

Helper's only coal mine was the Carbon Fuel Company No. 2 Mine, located in Hardscrabble Canyon. Operated by James and Chris Diamanti, the mine was known locally as the Hardscrabble or Diamanti Mine. At midnight on December 16, 1963, a gas and coal dust explosion tore through the mine. Mike Ardohain, Victor Fossat, Andy Juvan, Archie Larsen, Heino Liin, Beniono Montoya, Gerald Nielsen, John Senechal Jr., and Benjamin Valdez were killed, and Jesus Nunez was injured. The rest of the 21 men on shift escaped unharmed. Inseparable since childhood, friends Beniono ("Big Ben") Montoya and Benjamin ("Little Ben") Valdez shared a funeral service and were buried next to each other. This photograph was taken in the mine office after the explosion. Pictured from left to right, Steve Diamanti, Dr. O. W. Phelps, and Jim Diamanti give an update to the families. Helper physician Dr. Phelps was the only doctor to go underground during mine disasters until emergency medical technicians were required at all mines in the 1970s.

Three

SIX TOWNS IN SIX MILES

Directly west of Helper, the area known as Spring Canyon held six mining camps over a distance of approximately six miles. Each camp was individual and distinct, but with each one separated a distance of only a mile or less, the camps shared a commonality that other camps in the area did not have.

One of the most influential people in the Spring Canyon area was "Uncle" Jesse Knight, a Mormon capitalist with deep pockets. Under the leadership of George A. Storrs, Knight funded the initial mining operation and subsequent camp in Storrs later known as Spring Canyon.

Knight financially supported the construction of a railroad line from the mines in the canyon to the Denver and Rio Grande Western main line in Helper. The railroad venture was completed with the help of the Sweet brothers, who went on to open the Standard Coal Company in neighboring Standardville.

Beginning with Peerless and ending with Mutual, the Spring Canyon area towns and the nearby mines of Vulcan, Western, Maple Creek, Day's Mutual, and Little Standard produced approximately 53 million tons of coal over the course of their lifespan. Mining began in the canyon by 1900, with most of the mines closing by the late 1950s. Spring Canyon was the exception, remaining open until 1989. Long before the mine closed, the towns that had once flourished in the canyon lay deserted. However, true to their roots, the former residents of these camps gather together every year to celebrate Canyon Days with their old friends and neighbors from the six different camps.

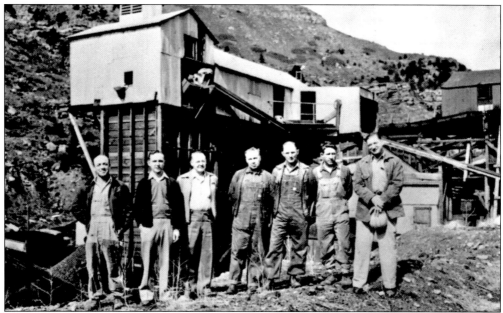

Founded in 1915, the first camp west of Helper along the Spring Canyon road was Peerless. Named for the Peerless Coal Company and started by Charles and William Sweet, Peerless operated until 1953. The supervisory staff at the Peerless Mine—from left to right, James L. Ori, Albert Fossat, Evan Jones, Charles Jones, Henry Draper, Vic Fossat, and Louis Vuksinick—pose at the tipple around 1925.

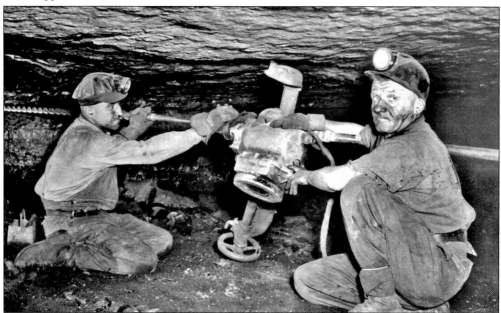

Where the Castle Gate area had thick coal, the seam in Peerless was thin. Averaging about 4 feet thick, the coal was called "crawler coal" by the miners because of the necessity of crawling on their hands and knees to mine. But while the coal seam was short, the mine produced up to 500 tons of coal per day. This c. 1920 photograph shows two unidentified miners preparing a drill in the short coal.

Located high on the mountainside in a canyon above the town, the Peerless Mine required a long steep tramway for the coal from the mine entrance to reach the tipple below. This c. 1920 image shows the tracks cutting through the rock in the canyon. The pine tree at the right of the photograph was often decorated by the miners at Christmastime.

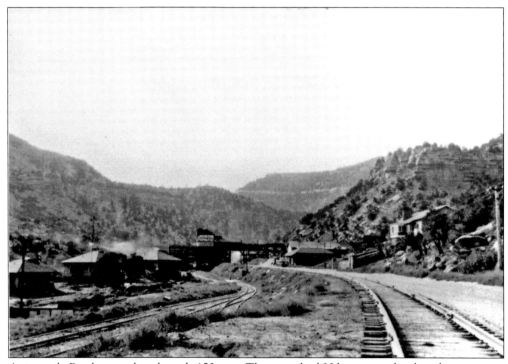

At its peak, Peerless employed nearly 150 men. The camp had 30 homes, a school, and its own post office. This photograph taken in 1929 shows the Peerless tipple in the background with several of the company homes visible on the left and the school on the right. The two sets of railroad tracks belong to the Denver and Rio Grande Western and the Utah Railway, respectively.

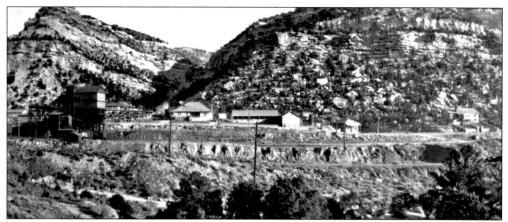

The mine officials at Peerless, like many other coal camps, lived as close to the mine operations as they could. This c. 1925 photograph shows the Peerless tipple with, from left to right, the steep tramway extending up the mountainside, the superintendent's home, and homes for the mine foreman, the mine electrician, and the tipple operator. The Peerless school is on the far right. (Courtesy SueAnn Martell.)

The owner of the Peerless Pool Hall, Nicholus Pappadakis (third from left in this 1917 photograph), emigrated from Greece. Pool halls and Greek coffee houses provided a comfortable atmosphere for the Greek miners to get together, socialize, and enjoy each other's tales from the old country. The pool hall appears to be on the main floor of the Greek boardinghouse.

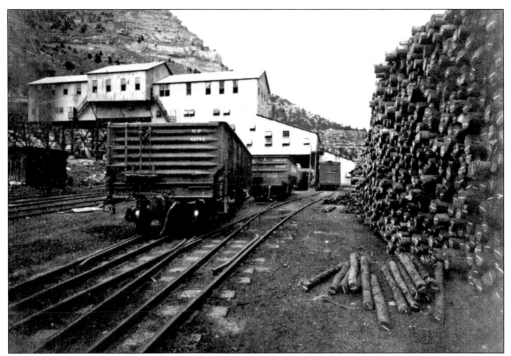

Located just west of Peerless and four miles west of Helper, the town of Spring Canyon began its life as Storrs. Founded in 1912 by "Uncle" Jesse Knight, the mining operation was run by George A. Storrs, a former railroad grader. Knight operated the Knight Investment Company. This c. 1930 photograph shows the tipple after the name was changed to Spring Canyon in 1924.

The Spring Canyon Mine entrance was located in a side canyon known as Sowbelly Gulch. The loaded coal cars traveled down the mountainside to the tipple in the main part of town while empty coal cars were pulled up using a pulley system. This photograph from 1958 shows loaded coal cars on their way to the tipple.

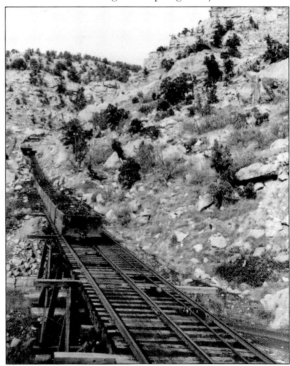

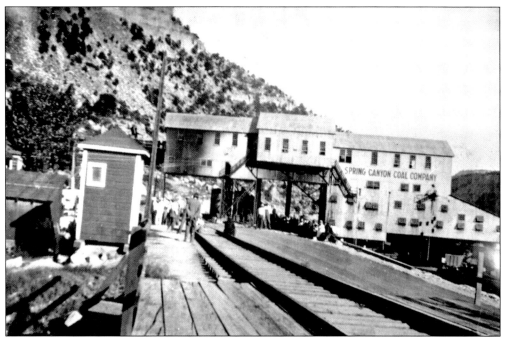

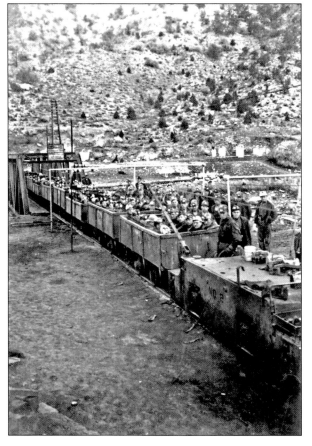

In times of labor strikes, coal mining and railroad operations were shut down by picket lines. This image taken in 1933 shows the striking miners surrounding the Spring Canyon Coal Company tipple in an effort to halt all operations. While times of strike in eastern Utah were often deadly, this incident was resolved peacefully.

By the 1940s, Spring Canyon had reached its peak population of just over 1,000 residents. The mines were at top production, and the workforce was large. This image taken in 1945 shows the miners seated in the mantrips, empty coal cars used to transport miners, preparing to enter the mine. Depending on where the miners were working in the mine, the trip in and out could take up to one hour.

A landmark of Spring Canyon was the Storrs Bakery. Owned and operated by Batista and Julia Anselmi, the Storrs Bakery was housed in a hand-hewn Italian stonemasonry building. Batista Anselmi used a paneled truck to travel through the towns of the Spring Canyon area selling baked goods. Often Italian immigrants would leave their work in the coal mines to return to farming. The farm peddlers would load a wagon with fruit, vegetables, and livestock and travel among the coal camps. Neighbors John Marchello and Gabriella Clerico had regular customers in the camps and their wagons could be seen daily along the roads. The mining companies frowned on peddlers in the camps as it took money away from the company-owned stores.

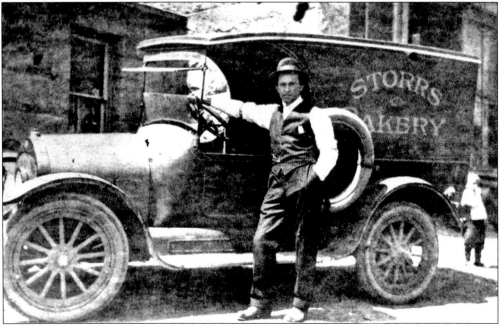

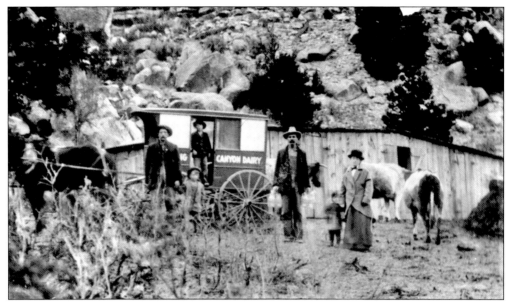

In addition to an Italian bakery, Spring Canyon also boasted its own dairy. The dairy provided fresh milk, butter, and cheese to the coal camps in the area and made its daily deliveries with the small wagon pictured here in 1915.

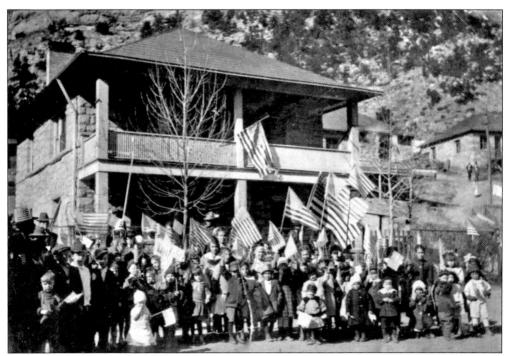

Spring Canyon developed into a booming, modern town with 63 sandstone homes with hot and cold water, its own school, and its own hotel. One of the unique additions to this coal camp was a public swimming pool that was heated with water from the mine's boiler plant. Every resident was encouraged to learn how to swim for free. Festivals and celebrations were held often, as seen in this World War I Victory Party in 1919.

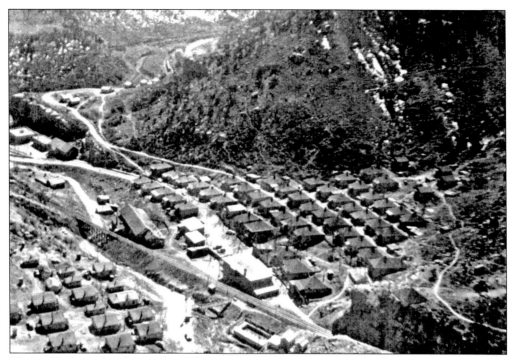

This c. 1948 overhead view shows Spring Canyon was one of the larger mining camps in the area. On the cliff in the top left of the image were the tennis courts and town flagpole. The rows of neat company houses lined each side of Sowbelly Gulch, while the business district was located at the base of the cliff below the tennis courts.

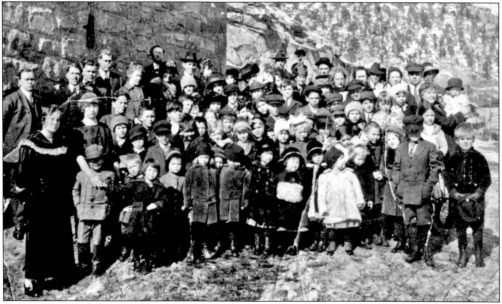

The Spring Canyon School offered education for all of the young children in the camp. Opened soon after the camp was founded in 1913, the Spring Canyon School taught grades one through nine. This c. 1913 photograph shows the students, teachers, school administrators, and some proud parents.

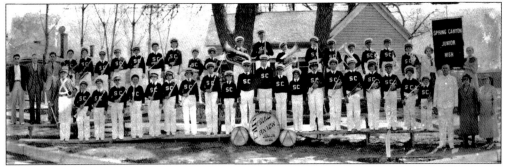

The Spring Canyon School had its own marching band. During the 1920s through the 1930s, Carbon County participated in Band Day. Officials invited regional bands from as far away as western Colorado to come and compete in music and marching competitions. The events drew people from all over the region to cheer on their favorite band. This photograph was taken around 1930, when Spring Canyon won several of these competitions.

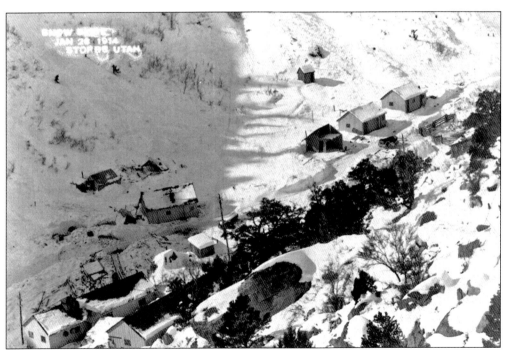

The steep, narrow canyons that made up Spring Canyon combined with the heavy winter snows at the high elevations have always been a deadly combination. On January 26, 1914, an avalanche swept down the canyon, burying four homes and killing three people. This photograph shows the path of the slide and the crushed homes.

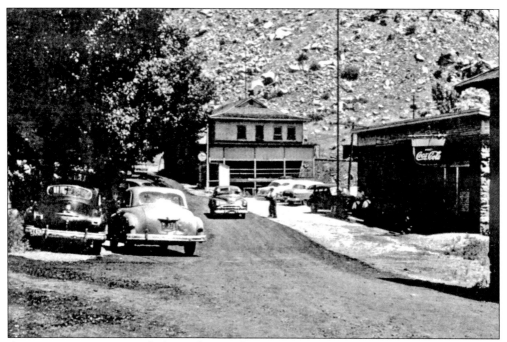

As transportation improved, the coal camps began to suffer a loss of residents. By the 1950s, it was quite common for the miners who worked in Spring Canyon to live in nearby Helper and make the short commute to work. With the miners' families living in another town, the coal camp began to die. This c. 1950 image shows the Spring Canyon Store on Main Street.

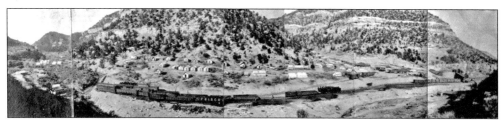

Just west of Spring Canyon was the camp of Standardville. Opened by Fredrick A. Sweet in 1912, Standardville was named because it was seen as the standard for all future mining camps. The town of Standardville was well designed and planned and offered all the amenities of a modern town. This c. 1912 photograph shows the early camp complete with tent homes.

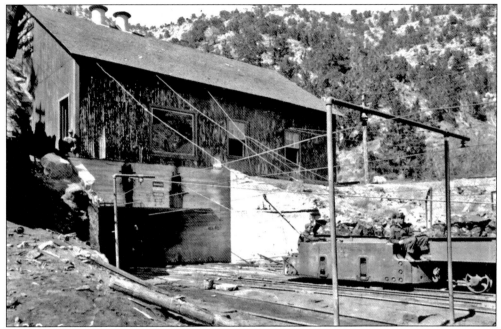

Located in a rich coal seam, the Standardville mine quickly began producing up to 200 tons of coal per day. The Standardville Coal Company opened and operated four mines in an area north of the town in Gilson Gulch. Here the Standardville No. 3 mine portal is seen around 1940 with a load of coal leaving the mine.

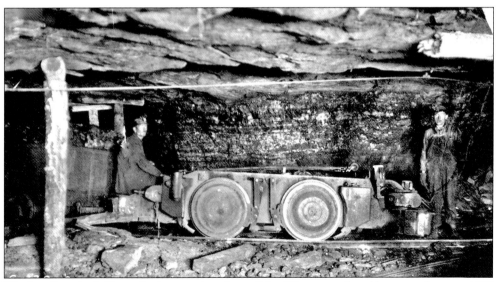

The four Standardville coal mines produced over 8.1 million tons of coal between the years 1913 and 1954, when the mine closed permanently. Miners inside the Standardville mine are preparing to surface with a load of coal around 1940. The large wooden timbers acted as roof supports.

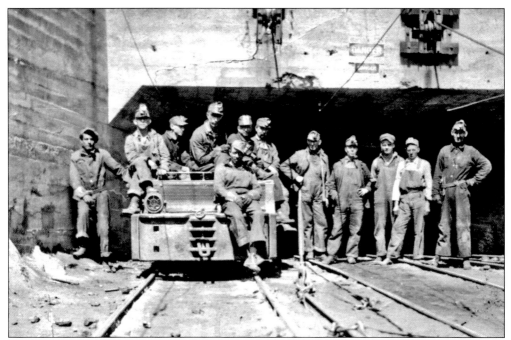

Another devastating mine disaster occurred at the Standardville mine on February 6, 1930. Twenty miners were killed when an explosion ripped through the mine. During rescue efforts, three rescue workers were also killed when a chunk of rock measuring 7 by 17 feet crushed them while they were trying to reach the stricken miners. This c. 1930 photograph shows men ready to enter the mine.

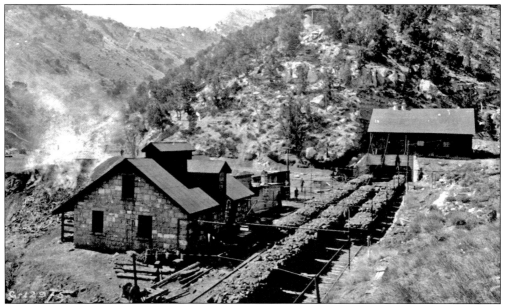

At their peak production, the mines of the Standardville Coal Company produced over 2,000 tons of coal per day, an average of 5,406 tons per acre with a 51 percent recovery of the coal reserves over the mine's lifespan. Here is the portal of Standardville No. 3 with tons of coal awaiting its descent to the tipple.

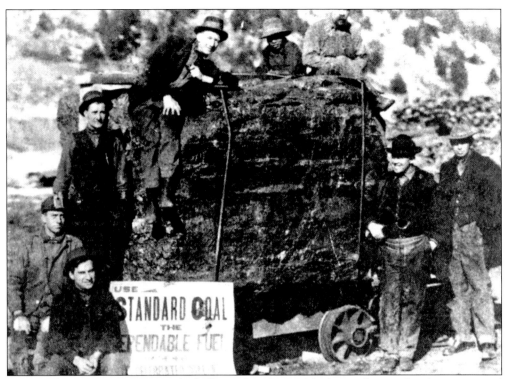

In the early 1920s, miners at Standardville produced one of the largest lumps of coal ever removed from a mine in one piece. Seeing the event as a good one for promotion, the Standardville Coal Company hired A. P. Webb Photography to come and photograph the occasion. The sign reads, "Use Standard Coal: the Dependable Fuel from the heart of Utah's Celebrated Coal Fields."

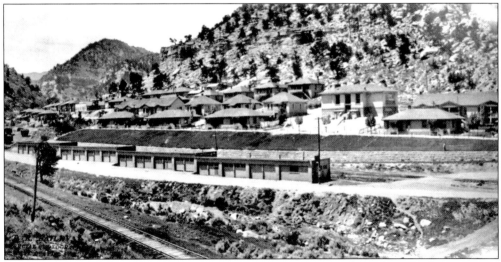

While Standardville became the model of the modern coal camp, in the early years of its existence, the camp had no culinary water. Residents who traveled to Helper took barrels for water and stocked up before heading for home. This c. 1930 photograph shows the lovely company homes with their neatly manicured yards, the school, and the rows of garages for automobiles.

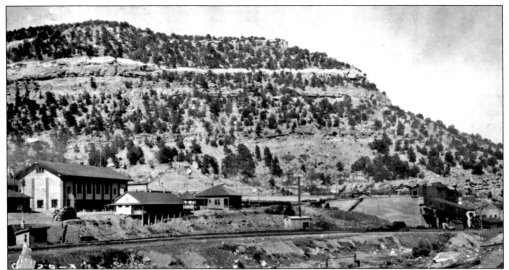

The large concrete wall of the Standardville tipple (far right) is still standing today. The Standardville Coal Company used the latest in technology to make the coal mining operation as efficient it could be. The impressive tipple building helped to quickly sort the coal into size without much breakage of the coal. The two-story building (far left) is the amusement hall.

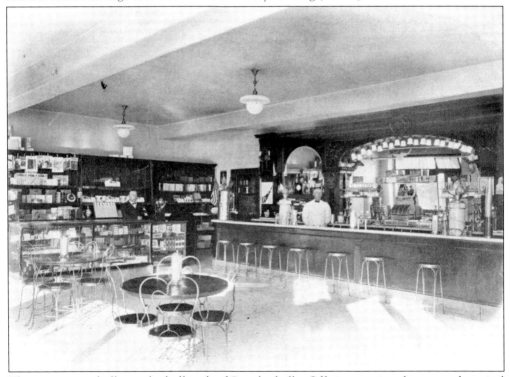

The amusement hall was the hallmark of Standardville. Offering movies, dances, and musical events, the amusement hall also had a confectionery store. This c. 1920 image is from a promotional pamphlet produced by the Standardville Coal Company. The double soda water fountain was made of marble and mahogany. The confectionery sold sandwiches, coffee, ice cream, and a wide variety of drugstore merchandise.

Another image from Standardville's promotional pamphlet showed the attractive and modern homes owned by the company. The building on the far left was the boardinghouse, which featured "wholesome meals furnished to the single men employed and also the public." While Standardville offered miners the most modern living, the population of the camp reached its peak in the 1930s with 550 residents.

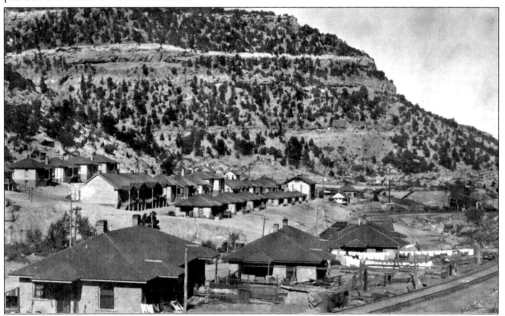

While not as neat and crisp as the photographs in the promotional pamphlet, this is a more lived-in view of Standardville around 1919. One of the harsh realities of life in a coal camp is that white laundry hung out to dry (lower right) will not stay white for long with the coal dust and steam engines.

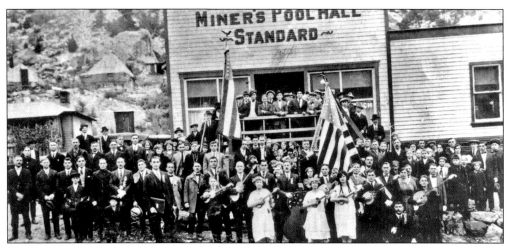

In 1922, the Tamburitza Band from nearby Sunnyside, Utah, traveled to Standardville for the christening of the Croatian Fraternal Union and the Slovenian National Benefit Society flags. The band was conducted by Nikola Bakarich and included Zalyah Plute Gormik, Caroline Nemenich Bezyak, Anna Tolich, Joe and John Myers, Jennie Chesnik, and Joe Skerl. The band members played stringed instruments from Yugoslavia.

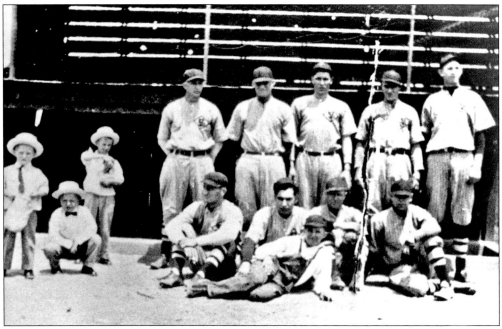

The Standardville baseball team had their own field in the camp and hosted other camps' baseball teams for some friendly competition. The team, managed by Frank Memory and Tom Lamph, included Luke Carmoni, Burt Happs, Curley Ruthebien Monroe, Sud Wayne Harriman, Harold Harriman, and Slim Allison. Pictured from left to right, the boys are George Wilson, Earl Harriman, and James Monroe.

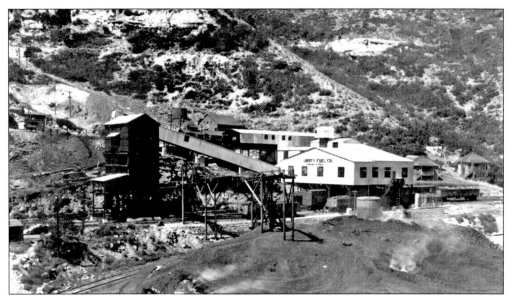

Located west of Standardville, the coal camp of Latuda was opened in 1917 by Frank Latuda and Frank Cameron. Originally called Liberty, the name was changed to honor mine owner Frank Latuda. Here is the large mine tipple and loading facilities with the name of the Liberty Fuel Company on the side.

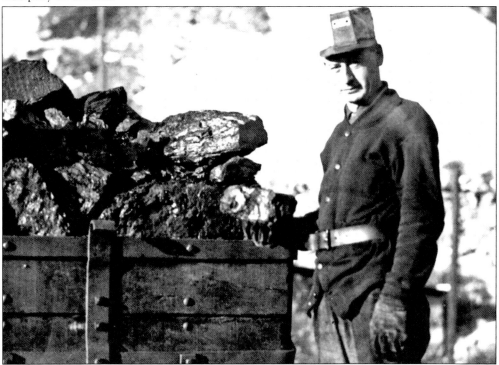

The Liberty Fuel Mines produced coal from 1917 to 1964. During that time, the company mined over 7 million tons of coal, and the mines are believed to be mined out. The superintendent of Liberty Fuel Company during the 1940s was George Schultz. Here Superintendent Schultz posed for a photograph with a loaded car of high-quality coal.

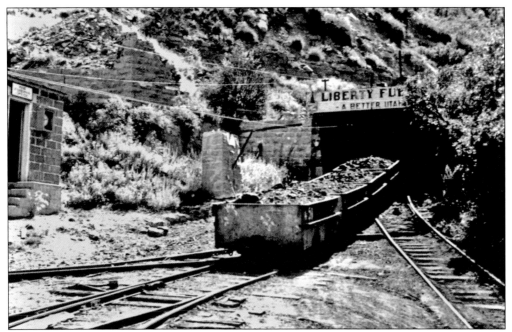

A fully loaded coal car is pictured coming out of the Liberty Fuel Mine in Latuda just before the mine closed for good in 1964. The small building at the left of the photograph was the powder shack where explosives were stored. The average thickness of the coal seam mined at Latuda was only 5 feet, but it produced a high-quality, clean-burning coal.

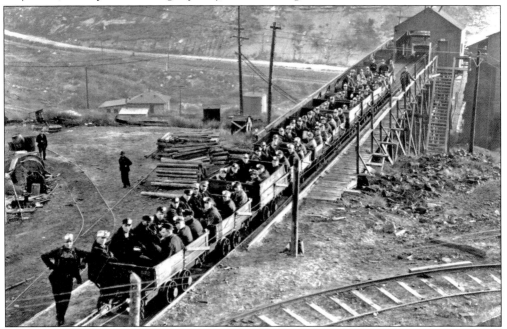

At the peak of the Liberty Fuel Mine's operation, there was a workforce of 110 men. The camp reached its peak population of 400 residents by the late 1940s. Here the loaded mantrip is ready to enter the Liberty Mine around 1940 with the main road through the canyon visible in the background.

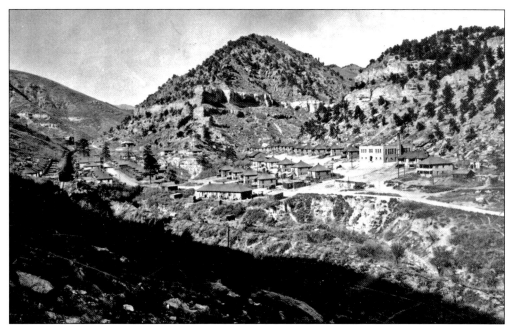

Though the earliest residents of Latuda lived in tents, the company soon built 20 homes with another 35 homes completed as the mine's prosperity increased. This c. 1923 image of Latuda shows these homes plus the large, newly constructed rock schoolhouse. In the upper left portion of the image, the mine office and mine tipple can be seen.

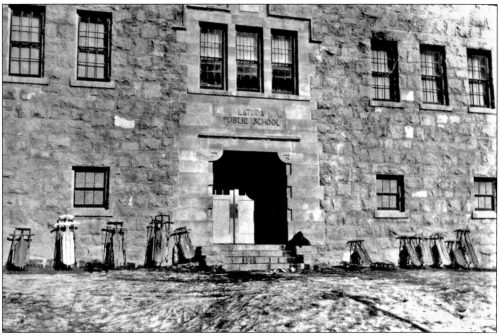

Taken in the winter around 1925, this image of the Latuda Public School shows the most common mode of transportation for students in the area—the sled. Students in grades one through six attended the school as well as junior high school–age students from the surrounding camps. Students in the 11th and 12th grades were bused to high school 12 miles away in Price.

The teachers and administrators of the Latuda school posed outside for a photograph around 1924. Pictured from left to right are Lewis Hunsaker, Mrs. Williams, Miss Tuddenham, Mrs. McDonald, John Pace, and Horase Rose. Rose married Tuddenham, and after her death, he married her sister.

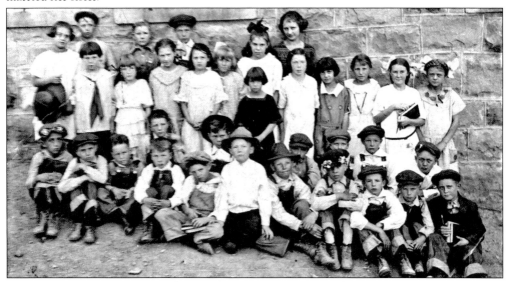

Before the Latuda Public School was built in 1923, classes were held in one of the nearby camp houses. The school was built out of local sandstone hand carved by Italian stonemasons. This c. 1925 photograph shows the students of the Latuda school preparing for their day of study.

While most of the mining camps of eastern Utah are considered ghost towns, Latuda reportedly has its very own ghost. For decades, the story of Latuda's White Lady has circulated throughout the area and hundreds of sightings have been documented. The White Lady is said to haunt the area around Latuda, especially the Liberty Fuel Company office, seen here around 1920, where she reportedly took her own life after a mine accident claimed her husband.

Located west of Latuda, the next town in the canyon was the camp of Rains. In 1915, under the direction of former opera singer Leon F. Rains, the Carbon Fuel Company opened an 18-foot coal seam. Located near the mine entrance, the bathhouse at Rains was one of the last structures to be torn down when the mine closed in 1958. (Courtesy of SueAnn Martell.)

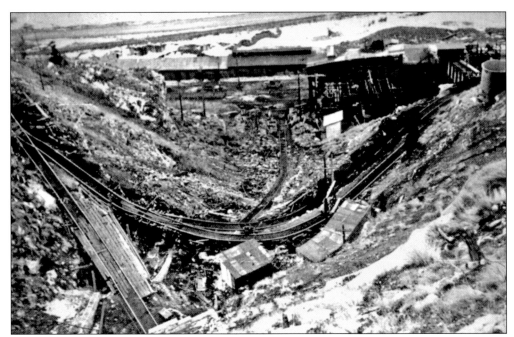

Leon F. Rains had been working for the Standard Coal Company when he acquired water rights in the canyon based on a Standard Coal Company water survey. Rains won a lengthy lawsuit after he opened his own camp. In an effort to market his rich, high-quality coal, the coal was sold under the name Hi-Heat Coal Company. This c. 1920 image shows an overhead view of the Rains tipple and mine buildings.

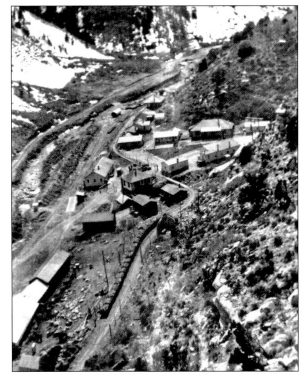

The town of Rains had all of the modern conveniences except indoor plumbing. The homes were small but comfortable, and soon the town had blossomed to include its own school, a boardinghouse, and its own store. This c. 1920 image shows the main road through town with houses scattered along the way.

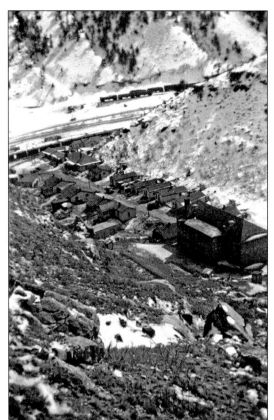

The homes in Rains left the main part of the canyon and went north into the side canyon near the mine. This photograph from 1938 shows the first group of homes coming into Rains. The large building on the right is the sandstone school built in 1921.

The students at Rains and nearby Mutual attended the school for grades one through six. After the sixth grade, the students traveled the short distance down the canyon to Latuda. Here, from left to right, are Mrs. Smith, Principal King, and Mrs. Moffat. Student Joe Cha is seen at the far right.

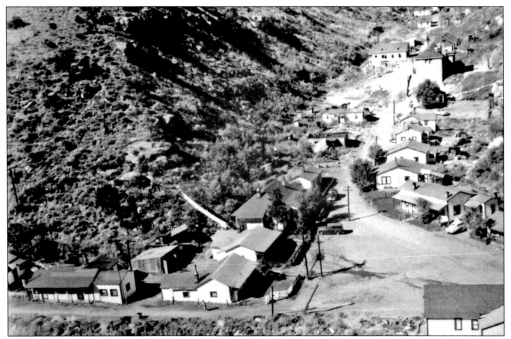

Life in Rains, like other coal camps, was difficult but also joyous. In the evenings, the camp was alive with dances, free movies, and talent shows. At it peak, Rains reached a population of over 400 people. This c. 1938 photograph shows the mine superintendent's house on the corner and the schoolhouse in the upper right corner.

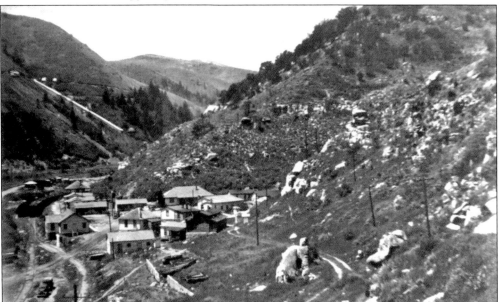

This c. 1920 photograph shows the nearby Maclean Mine. The Maclean Mine was located high up on the mountainside across from Rains. The tramway was very steep, and although the Maclean was owned by the Standard Coal Company, the coal was processed at the Rains tipple. The Maclean Mine closed in the 1940s after the mine caught on fire. The fire still burns in 2008 deep underground.

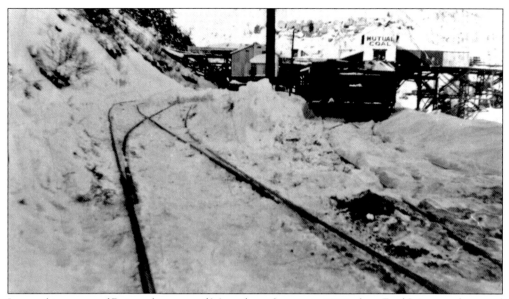

Located just west of Rains, the town of Mutual was begun in 1920 when Fred J. Leonard opened the Mutual Coal Company. Three rich seams of coal—one 8 feet thick, one 4 feet thick, and one 6 feet thick—were located in the canyon known as Burnt Tree Canyon. This image shows the newly constructed tipple at Mutual around 1921.

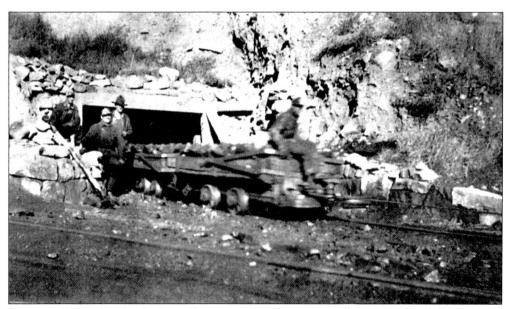

Between 1922 and 1938, the Mutual Mine produced over 2.4 million tons of coal. In 1938, the Mutual Coal Mine closed, although people still lived in the town to work at nearby mines. This c. 1930 photograph shows loaded coal cars leaving the mine. The front car has a rope regulator in the front to control the cars' speed.

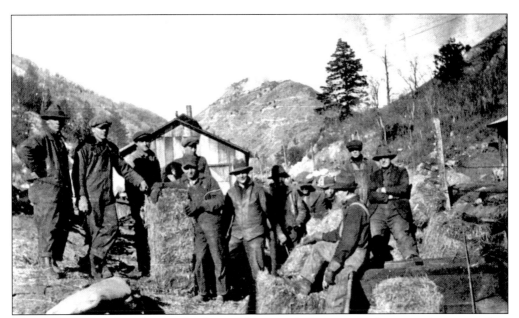

The mine at Mutual made use of mules and horses to help move the heavy coal cars as well as perform other duties. It was the tipple crew's job to stock the mine barn with hay for the animals. This 1927 photograph shows the crew taking a break from moving the hay bales.

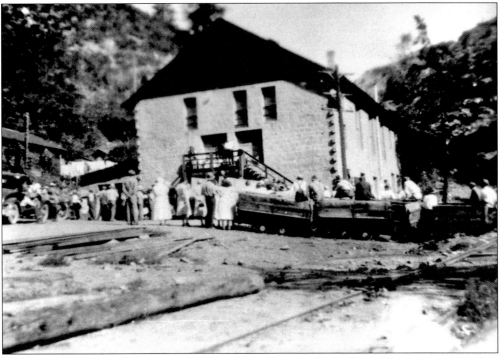

The large, rock Mutual Store was built by John Arronco Sr. in 1920. The store was used as neutral ground during the formation of the labor unions because it was not owned by the mine company. This image taken in 1933 shows a meeting of the newly formed United Mine Workers of America Union in Mutual.

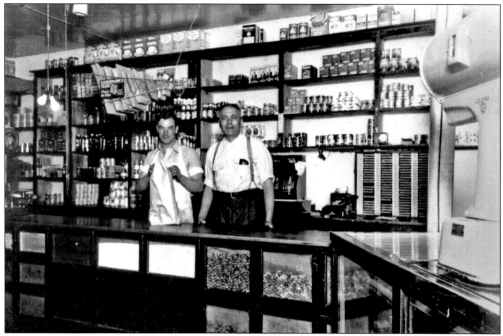

The Mutual Store was built by John Arronco Sr. and managed by Joe Pavignano. This image shows John Scarsi (left) and Joe Pavignano (right) inside the Mutual Store in 1937. Although the coal mine at Mutual closed in 1938, the Mutual Store remained in operation until 1954 to provide a nearby store for the remaining residents of Spring Canyon.

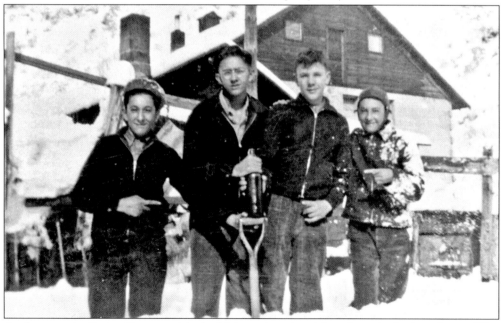

As the camp in Spring Canyon with the highest elevation, Mutual received a lot of snow. This image from 1938 shows, from left to right, Fred Cha, Joe Cha, Albert Pavignano, and Laurence Cha shoveling the knee-deep snow in front of the Cha home and the Mutual Store. It looks as if the boys had a little extra something to keep them warm.

Four

IN THE SHADOW OF KENILWORTH CASTLE

Coal was discovered near the future site of Kenilworth in 1904 by Heber Stowell, who was searching for some lost horses. Stowell opened the Bull Hollow Mine, and shortly afterward, the Aberdeen Mine was opened by the Price Trading Company. It was not until 1906 that the town of Kenilworth was founded by the Independent Coal and Coke Company.

Independent Coal and Coke Company was part of a movement in the area to get the coal reserves out of the hands of the railroad companies. Frustrated by the Denver and Rio Grande Western Railroad, which owned and operated the mines at Castle Gate, Clear Creek, and Sunnyside, the new mining company formed with the statement that they were independent from any railroad. Spearheaded by Arthur Sweet, who worked to open several other independent coal mines in the area, Independent Coal and Coke was very successful in their operations.

The coal camp of Kenilworth received its unusual name from the English immigrants who thought the towering sandstone cliffs that surrounded the area resembled the walls of their beloved Kenilworth Castle in their former home. Located at an elevation of nearly 7,000 feet, Kenilworth has one of the most breathtaking views of the Price River valley and is arguably one of the most scenic of all of the coal camps. Although no longer a mining camp, Kenilworth still survives and is in fact seeing revitalization. In 2006, Kenilworth celebrated its 100th birthday, a milestone nearly unheard of in the boom-and-bust mining camps. Residents gathered together to talk about the good times and bad, to renew old friendships, and to remember what life was like in the shadow of Kenilworth Castle.

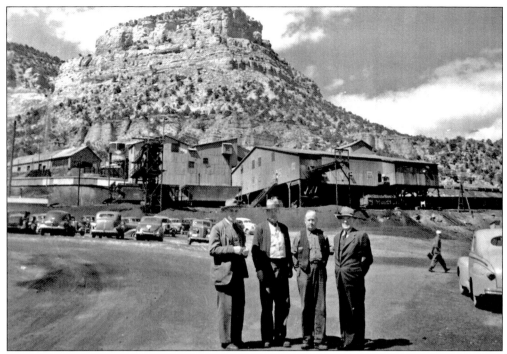

Five miles east of Helper at an elevation of 6,800 feet sits the town of Kenilworth. Opened in 1906, Kenilworth was operated by the Independent Coal and Coke Company. This c. 1945 photograph shows, from left to right, John Tonkin, general manager; Walter Clarke, superintendent; Roy Robbins, mine engineer; and Sam Woodhead, secretary treasurer, in front of the tipple.

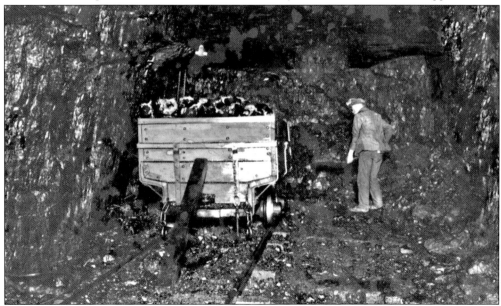

Located high on the mountainside, the Kenilworth Mine was situated in the rich Kenilworth or Castle Gate D coal seam, believed to be the most valuable seam in the Book Cliff coal region. Inside the mine, the Kenilworth seam reached a height of 22 feet. This image was taken inside the mine around 1910.

Between 1906 and 1908, the first residents of Kenilworth lived in the wooden-sided, canvas-topped tents seen here in 1907. In 1908, the first homes were built for the miners and their families. By 1910, Kenilworth's population had reached 500 residents.

Kenilworth reached its peak population in 1947 with approximately 1,050 residents. The town was built as close to the mining operations as possible, and the mining company encouraged visitors to the mine workings. This image shows, from left to right, Mr. Butterworth, Mrs. Boardman, and Jennie Beneclick with one of the mine locomotives at the mine tipple.

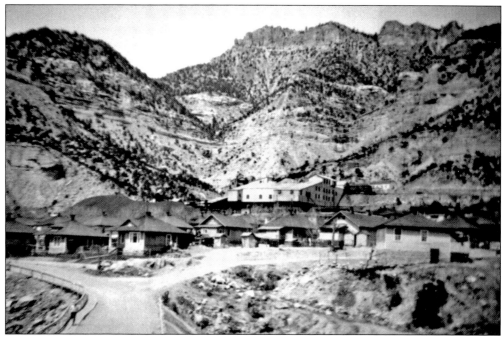

The town of Kenilworth was designed by self-taught Salt Lake City architect E. B. Phippen. Phippen designed the homes, the company store, the hospital, and other community buildings in town. Like most mining camps, Kenilworth was segregated by ethnic groups. The town boasted Greek Town, New Town, and Silk Stocking Row, where the mine officials lived. Here are the main part of town and the tipple as seen from New Town around 1930.

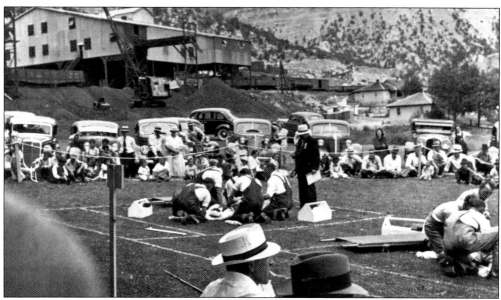

Kenilworth was not immune to mine disasters. On March 14, 1945, an explosion rocked the mine, killing seven miners and injuring several others. Between 1906 and 1970, at least 65 men lost their lives in the mine. This photograph shows a mine rescue contest held in front of the Kenilworth tipple in 1950.

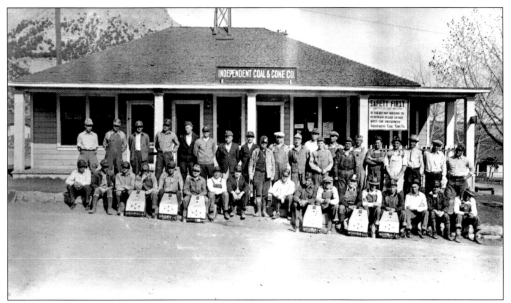

The Independent Coal and Coke Company trained their own mine rescue teams. These men were called upon to perform search-and-rescue operations in the dangerous conditions after an explosion or cave-in. This c. 1940 image shows the mine rescue class outside of the mine office. The sign above them on the building says, "Safety First. Safety is our Motto. If you are not willing to cooperate please do not apply for employment. Independent Coal and Coke Co."

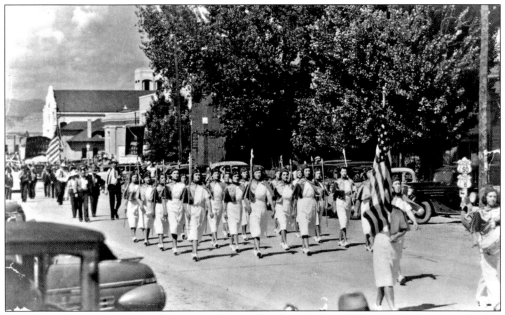

The United Mine Workers of America Union Kenilworth Local No. 1 had their own Ladies Auxiliary. The women are marching in the Labor Day parade in Price, Utah, around 1935. The flag bearer is Mandy Tittle, and the majorette is Ora Leavitt. Other members included Hattie and Olena Blackham, Florene Berensen, Jennie Pappas, June Mackey, Vivian Jones, Katie Bruce, Rhea Burns, Lizzie Williams, Renea Gordon Dixon, and Jackie Arterberry.

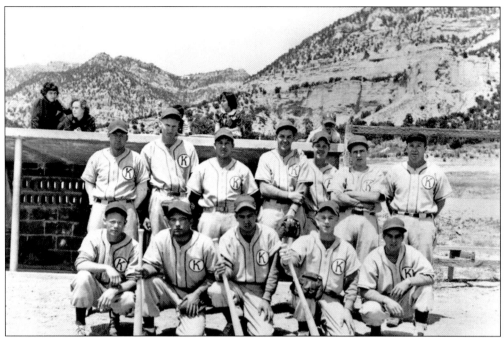

The Kenilworth Aberdeen Coal baseball team played from 1947 to 1961. The team, pictured in 1959 at the Kenilworth baseball field, took the honors as the Coal League Champions. From left to right are (kneeling) Ronald Jewkes, manager Eugene Crocco, Larry Regis, Tom Conover, and Willie Musgrove; (standing) Floyd Zemlock, Cick Trauntevein, Paul Montoya, Paul Johnson, Carlyle Berensen, Louie Crocco, and Frank Bandetti.

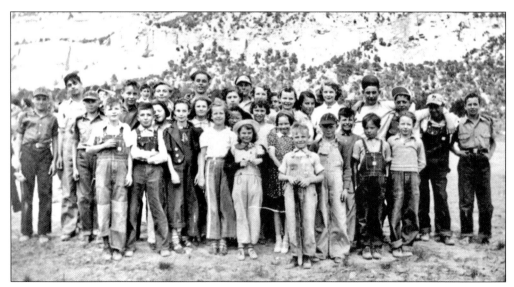

Kenilworth had its own school for grades one through eight and had three principals—Kate Sutton, Vern Rampton, and Lorus Winn—over its many years of service. Here is the Kenilworth School on a May Day picnic in 1938. The students pictured included two Western Mining and Railroad Museum volunteers, Guy Adams (far left) and Ron Jewkes (first row, fourth from right).

The Independent Coal and Coke Company organized a welfare association, and every miner paid $1 per month into the fund. In return, the coal company offered a movie every week, swimming at either the Price or Helper swimming pools, Santa Claus at Christmas, dances, and programs, all free of charge for the residents. The Kenilworth Auditorium was built in 1911 to serve as a community center for these activities.

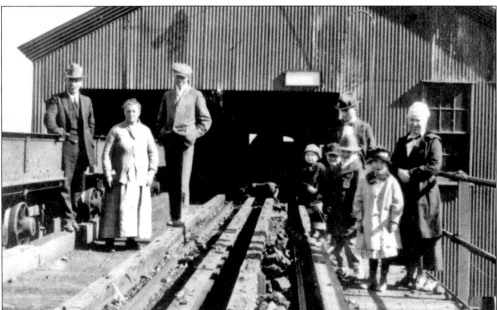

Kenilworth's population was overwhelmingly foreign born. At one time, 64 percent of the residents were born overseas, with the majority coming to America from Greece and Italy. New immigrants to town arrived in their new home by rail and had their first experience with coal mining when they disembarked at the tipple. These immigrants arrived in Kenilworth around 1920.

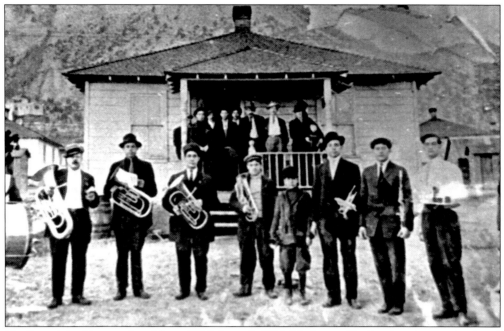

Kenilworth had its own band from 1906 through 1916. Made up of Italian immigrants, it played for funerals and special occasions. This photograph shows the band in front of a camp home in 1916. Band members included Bob Carnivali (second from left), John Ruggeri (third from left), and Fred Bonza (sixth from left).

The coal mine was literally a part of everyday life in Kenilworth. In an effort to mimic the outlaws of days past, Kenilworth children Ron Jewkes (right) and Bernard Bailey "borrowed" two of the mine horses and "robbed" the other children in town around 1930 in a rendition of Butch Cassidy and the Sundance Kid.

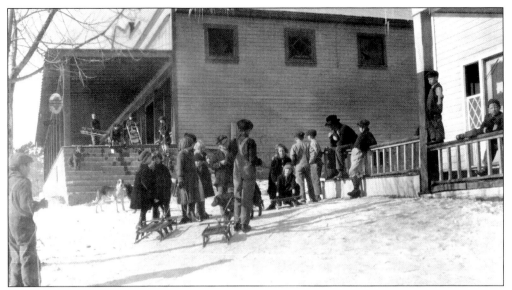

Serving as the center of the community, the Kenilworth Mercantile Company around 1960 was owned by the Independent Coal and Coke Company and managed by six different store managers. The last manager was Calvin Jewkes, who operated the store through the 1970s. The store was a gathering place for the community and offered all types of foods and dry goods. The store even offered gasoline for sale at a pump near the street.

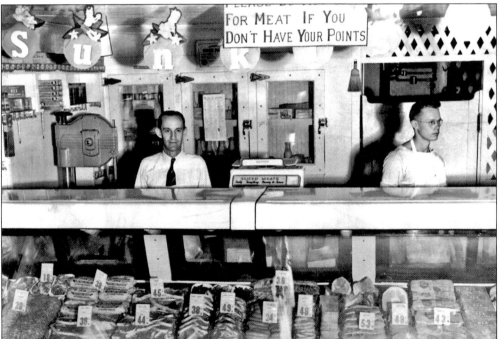

Inside the Kenilworth Mercantile was a full-service butcher shop. Butcher Keith Nielsen (left) and his assistant Ron Jewkes were photographed around 1943. During World War II, residents were rationed on the amount of meat they could purchase. The sign above the counter reads, "Please do not ask for meat if you don't have your points." Hamburger was available for 28¢ per pound and four ration points.

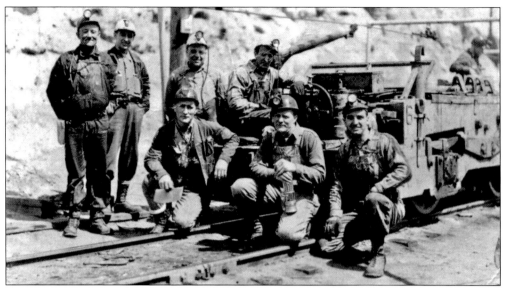

Between 1906 and 1970, the Kenilworth coal mines produced 36.2 million tons of coal. This image of the mainline motormen was taken around 1940. Pictured from left to right are (kneeling) Lloyd Catlin, Henry Trauntvein, and Pete Pero; (standing) Elburn Nelson, Bill Jackson, Sam Angotti, and Johnny Senechal.

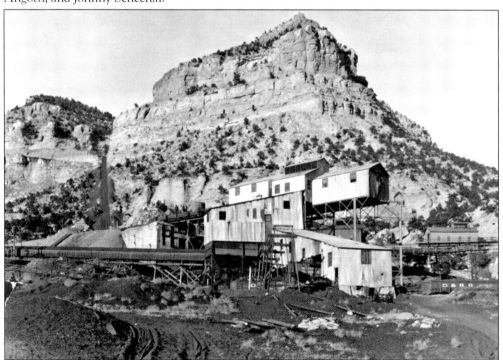

The tramway going from the mine entrance to the Kenilworth tipple was a staggering 700-foot drop. The miners had wooden sleds made to fit the rails so they could descend the tramway quickly. In an effort to initiate new workers, sleds were greased, giving the miners the rides of their lives down the mountain and more than a few skinned miners. This image was taken around 1920 and shows the tramway of the mine.

Five
"Dempseyville" and the Wasatch Plateau Trio

In another unique coal mining venture, the area known as Gordon Creek was opened for mining in 1921. Named after James Deseret Gordon, who homesteaded the land in 1889, the property was bought by George Storrs. Storrs laid out a map of a town he called Great Western. George Storrs formed a cooperative and sold small tracts of land to miners in exchange for them becoming stockholders in the effort. The miners were required to farm their land to provide for the cooperative when they were not working in the mine.

In 1923, the town of Great Western welcomed its most famous resident. Heavyweight champion Jack Dempsey moved into the town to train. Dempsey became interested in the coal mining of the area and told mine officials he would like to invest in the mines. Thrilled with the prospect, the town's name was officially changed to Dempsey City, or Dempseyville as the locals called it. In 1924, Dempsey decided not to invest in the mines and the name was changed to Coal City.

A few miles west of the town of Coal City, three additional coal camps also got their start in the early 1920s. The largest of the three was originally called Gibson after A. E. Gibson, the founder of the coal deposits in the area. Soon two additional towns, Sweets and National, were settled by brothers C. N., H. W., and Fred Sweet.

Located next to each other in the foothills of the Wasatch Plateau, the three towns shared a post office, a school, and other amenities.

The mines in the Gordon Creek area produced over 5.5 million tons of coal from 1925 to 1970. While all of the other mines in the area have closed and been reclaimed and the towns left to fade away, the mine at Consumers (Gibson) is still being mined today.

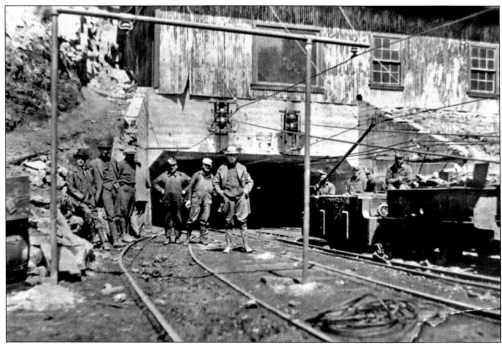

In 1921, the town that would become Coal City was established. Originally called Great Western, the area soon attracted world heavyweight champion Jack Dempsey. This image shows Jack Dempsey (third from left) touring one of the coal mines in the Gordon Creek area. The town was briefly named Dempseyville or Dempsey City, but when the champion decided not to invest, the town became Coal City.

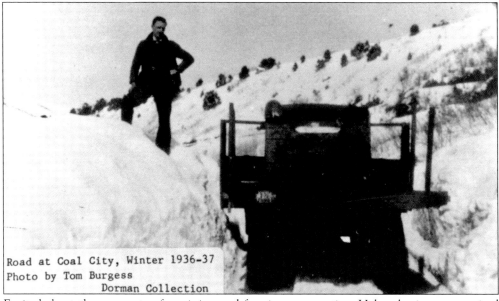

Road at Coal City, Winter 1936-37
Photo by Tom Burgess
Dorman Collection

Excited about the prospects of a mining and farming cooperative, Helper businessmen raised money and helped to build a road to Coal City from the adjacent Spring Canyon. Located on the flank of the Wasatch Plateau, the Gordon Creek area received large quantities of snow every winter. This is the road to Coal City in the winter of 1936.

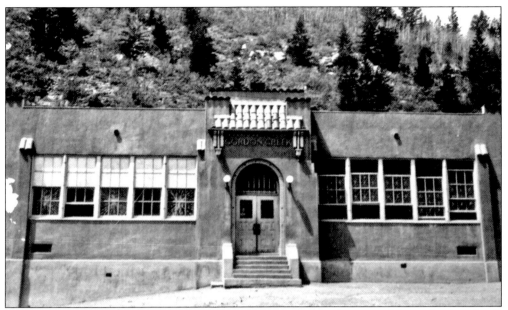

Clustered together at the base of the Wasatch Plateau, the area known as Upper Gordon Creek held the three separate mining camps of National, Consumers, and Sweets. Because of their proximity to one another, the camps shared several services. National, the camp farthest east, had the post office and the school shown here in 1935.

The mining camp of Consumers was founded in 1922 under the name of Gibson after Arthur E. Gibson. Shortly afterward, Arthur Gibson received financial backing and began the Consumers Mutual Coal Company and the town's name was officially changed to Consumers. Housing was modest, with many of the homes made of tar paper like the one pictured here around 1930.

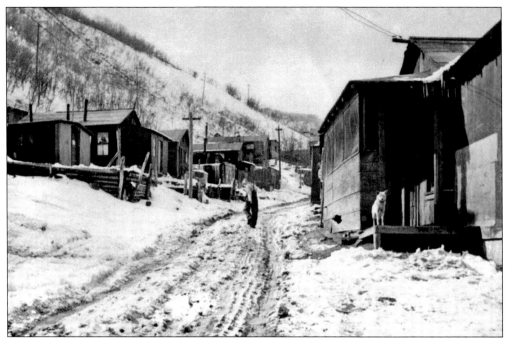

In the mid-1930s, with the country in the grip of the Great Depression, photographer Dorothea Lange accompanied the Federal Resettlement Administration to Carbon County with the idea that the only chance the miners had was subsistence farms and government-subsidized housing. Dorthea Lange's powerful images from 1936 did little to deter the idea that the coal mining areas of Utah were little more than shanty towns. Lange's camera captured the miners coming off of the day shift at the Consumers Mine and heading for their homes or the boardinghouse (below, far right) with the Consumers tipple in the background.

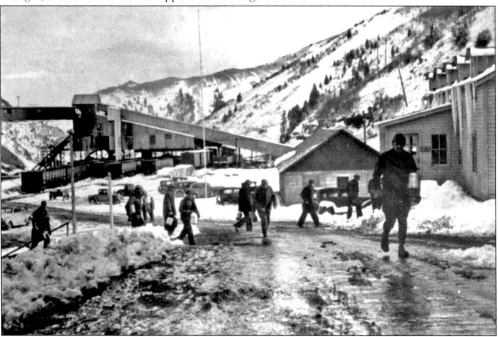

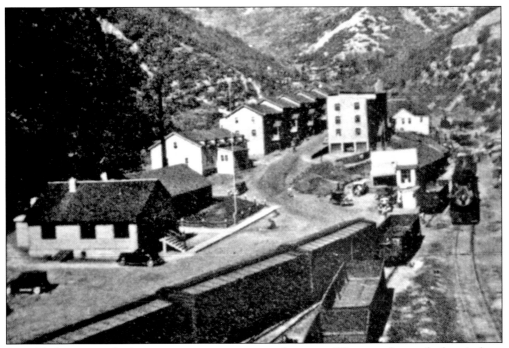

By 1937, Consumers had seen vast improvements to the camp. The town boasted a hospital, an amusement hall, its own store, and a service station, as well as a four-story apartment building and a 20-stall car garage. This image from 1937 shows the apartment building, the store near the tracks, and the mine office.

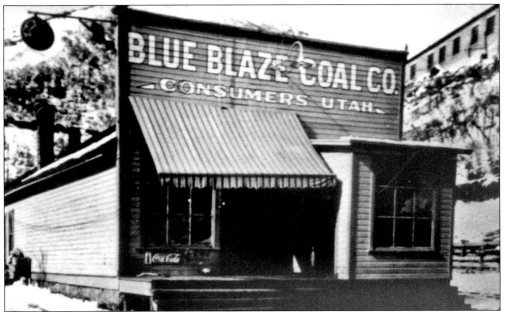

Also in 1937, the Consumers Mutual Coal Company changed its name to the Blue Blaze Coal Company. While the three Gordon Creek camps shared some amenities, each one had its own company store. And while the only homes in the camps that boasted indoor plumbing were the mine officials' homes, each camp had its own spring where residents could fill water jugs.

Like other coal mines, the Consumers Mine was very dependent on the economy and opened and closed accordingly. In 1938, one year after this photograph was taken, the Consumers Mine closed abruptly after hiring new miners that very morning. The mine reopened and continued to produce, although the town was abandoned by the 1960s. Today a modern coal mining operation is still mining the Consumers area.

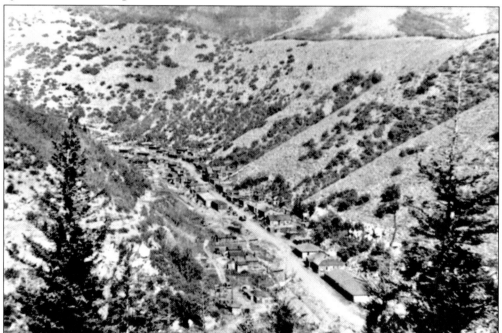

Just south of Consumers was the coal camp of Sweets. Founded in 1921 by Frederick Sweet, Sweets Mine was active from 1925 through 1940 and then intermittently through 1952. This image shows an overhead view of the town of Sweets. Sweets' neighboring coal camp, Consumers, was located just over the ridge on the right of the photograph.

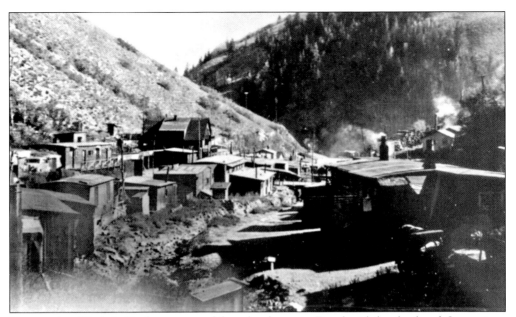

New mother Virginia Cochrane moved from her home in Royal with her husband, James, into Sweets, where James's father worked as a mine official. The Cochrane family was housed in one half of the lamp shack. As the miners prepared for work, they would enter the lamp shack and pass through the Cochranes' living area with a cheerful "Good morning, Mrs. Cochrane." This image from 1937 shows Sweets' Main Street.

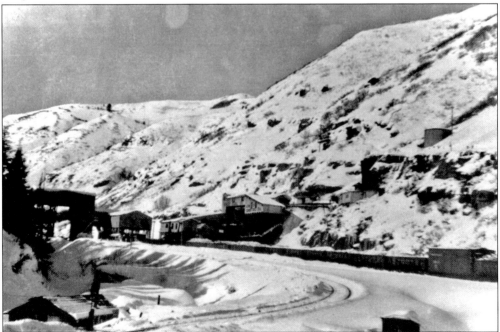

The Sweets Mine produced more than 1.5 million tons of coal during its years of operation, and the population of Sweets reached its peak with approximately 200 residents. The entire Gordon Creek area produced between 5.3 and 5.5 million tons of coal through the 1960s. Here is the tipple at Sweets in 1937.

As part of the formation of the National Coal Company and the Gordon Creek Coal Company, the companies formed their own railroad line to the mine sites. This line (pictured above), known as the National Coal Railway, was built in 1925 by the Utah Railway. The line connected with the Utah Railway at National Junction and traveled 8.9 miles to the Sweets Mine. Here is the Gordon Creek Trestle at the mouth of Sweets.

Located nearly 20 miles away from the population centers of Price and Helper, the Gordon Creek coal camps relied on the services of coal camp doctor J. Eldon "Doc" Dorman. Dr. Dorman's services ranged from delivering babies to removing bullets at the kitchen table with the help of some pliers and a good dose of medicinal whiskey after a particularly festive Saturday night and, of course, treating those who were injured in the mines.

Six

Coal to Make Steel

Located in the Book Cliff mountains overlooking the area known as Clark's Valley, Sunnyside was originally settled as a ranching community. Three notable characters—Jefferson Tidwell, a Mormon from Nauvoo, Illinois; Lord Lewis A. Scott Elliot, a nobleman from England; and the Whitmore family—settled the area. Lord Elliot soon discovered that ranching in an arid climate left a lot to be desired and by 1890 filed for a coal certificate on the lands surrounding his ranch, with the Tidwells following closely behind in 1896.

The coal in the Sunnyside region was discovered to be an excellent coking coal. Coke is a necessary part of the manufacture of steel, and a good coking coal was highly valued. Prior to the opening of the mines at Sunnyside, the Denver and Rio Grande Western Railroad operated coke ovens at their mine in Castle Gate with poor results.

Coke is produced when coal is baked in an airless oven at high temperatures. By 1898, the Pleasant Valley Coal Company, a subsidiary of the D&RGW, bought the properties at Sunnyside from the Tidwells and began coking operations there in 1903.

Sunnyside was owned by the Utah Fuel Company and the Kaiser Steel Company. The mines provided coke for the operation of the Kaiser's Fontana Steel Plant in California, which in turn provided the steel plate for Kaiser's shipbuilding ventures.

Sunnyside was not the only coal game in town. Three miles southwest of Sunnyside, the town of Columbia sprang up to support the U.S. Steel Company mining operations in 1922. Operating its own coke ovens, Columbia shipped its coke to the company's Geneva Steel Plant in Orem, Utah. By the 1940s, the Defense Plant Corporation opened an additional mine in nearby Horse Canyon to keep up with demand.

Today the town of Sunnyside still exists; the nearby towns of Dragerton and Columbia combined forces and formed East Carbon City in 1973. With the close of Geneva Steel in the late 1990s, the age of steel came to an end in eastern Utah's coalfields.

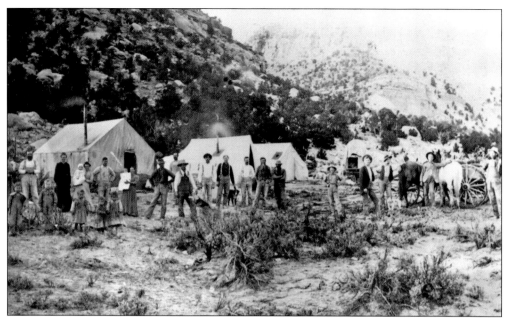

In 1896, John, Jeff, and William Tidwell began working a visible coal seam in Whitmore Canyon north of the future town of Sunnyside. The Tidwells were the sons of Jefferson Tidwell, an early settler of Carbon County. This c. 1890 image shows the budding town site of Sunnyside after the mine was purchased by the Denver and Rio Grande Western Railroad.

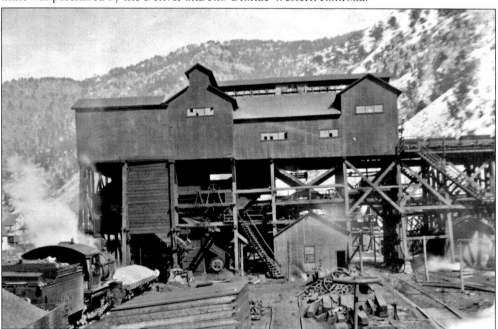

The Denver and Rio Grande Western Railroad, under the name of the Pleasant Valley Coal Company, bought the mine from the Tidwells when it was discovered that the Sunnyside coal was a better quality coal for coking than the coal at Castle Gate, which they also owned. Production was so high that Sunnyside required two tipples. This image shows the upper tipple around 1940.

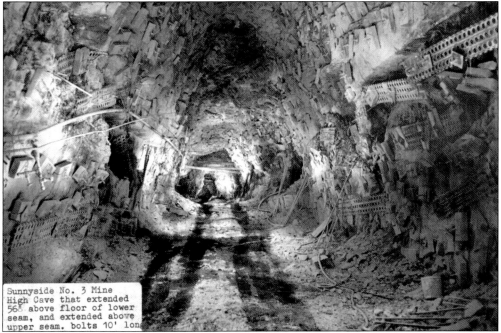

Sunnyside No. 3 Mine High Cave that extended 56' above floor of lower seam, and extended above upper seam. bolts 10' long

Sunnyside opened and operated three mines in the Whitmore Canyon area. From the earliest workings in the area, the mines were subject to frequent coal bumps or bounces, where the coal and rock bounce off of the walls and the roof. This c. 1940 image shows the so-called High Cave of Sunnyside No. 3 covered with 10-foot-long roof bolts. The top of the cave is 56 feet high.

Always at the forefront of mine safety and technology, the mines at Sunnyside developed cutting-edge ways to protect miners and equipment from the oftentimes deadly bounces. One of techniques used was steel support beams, shown here in this 1957 image from the main slope of the Sunnyside No. 2 mine.

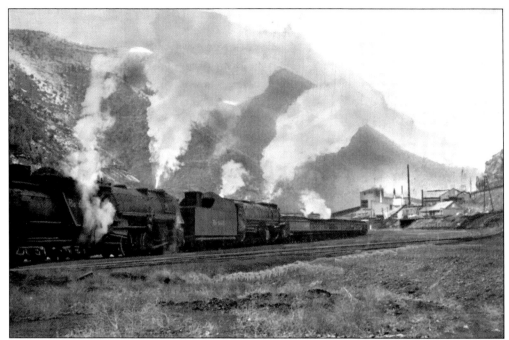

In 1899, the Denver and Rio Grande Western Railroad built a branch line from the siding at Mounds to the mine workings at Sunnyside under the direction of Samuel Naylor. On November 9 of that year, the branch line saw its first train. This c. 1940 photograph was taken just outside the Sunnyside tipple.

The Pleasant Valley Coal Company was reorganized into the Utah Fuel Company by 1900. The Utah Fuel Company owned and operated the mines at Winter Quarters, Clear Creek, Castle Gate, and Sunnyside. On March 5, 1951, the mines were sold to the Book Cliffs Coal Company, who had just merged with the Kaiser Coal Company. Here is the Utah Fuel Company office just before the merger in 1951.

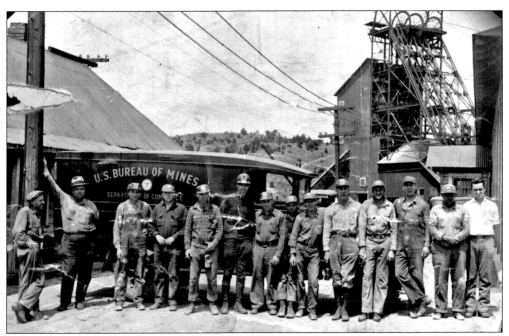

In the early 1900s, the U.S. Geological Survey formed its Technologic Branch funded by a tax on coal production. This bureau would investigate accidents and provide financial relief to victims. By 1910, it was reorganized to become the U.S. Bureau of Mines. Although a step forward in mine safety, the bureau was only able to make suggestions, which companies could then ignore. This photograph was taken in Sunnyside around 1945.

Sunnyside, under the ownership of the Kaiser Steel Company, continued to make advancements in the coal mining industry. In the early 1960s, the Sunnyside Mine was the first coal mine in the western United States to mine with a longwall. The longwall is a large mechanical miner developed in the United Kingdom. Longwall foreman James Cochrane (left) and an unidentified miner are pictured inside the Sunnyside mine around 1960. (Courtesy SueAnn Martell.)

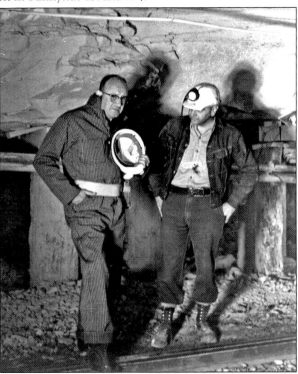

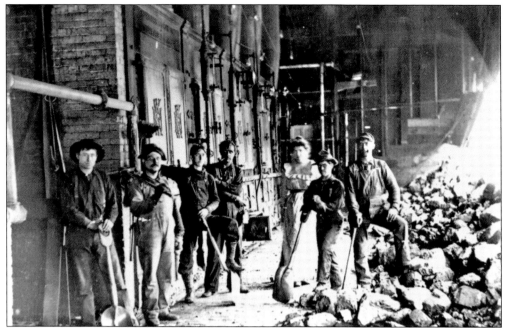

In 1898, Sunnyside coal was discovered to be of an excellent quality for coking. Until that time, all of the eastern Utah coke was produced at Castle Gate with moderate results. Coke is coal that has had all of the volatile properties of the coal, such as water and coal tar, driven off by baking the coal at extremely high temperatures in 12-foot-diameter brick ovens. This by-product is necessary in the manufacture of steel, where the coke is used as blast furnace fuel. Good-quality coking coal is based on the coal's moisture content and sulfur and ash content. Sunnyside began their coking operations in the early 1900s (upper photograph) and by 1919 had the largest operation of beehive-shaped coke ovens in the United States with 819 ovens. The bottom image shows the construction of these ovens around 1918.

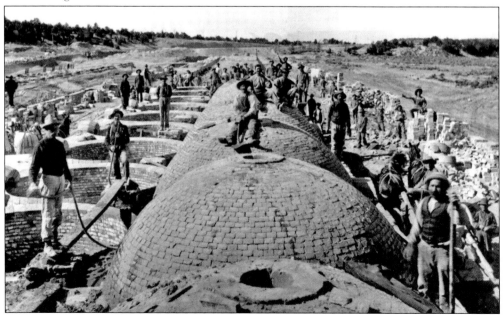

Although renowned for its coal and coke, Sunnyside was also a large producer of rock asphalt, a substance similar to tar and oil shale. The quarry was opened in 1892, and by 1927, a 3.5-mile aerial tramway had been completed to more efficiently move the crushed rock asphalt down the mountain. Each of the large metal buckets moved approximately 2,200 pounds of material down the 2,000 feet from the quarry to the bottom terminal. The tramway operated by gravity with each of the support towers acting as counterweights for the heavy ore. At its peak production, the tramway moved 70 loaded buckets per hour. By the mid-1940s, the asphalt was removed from the quarry by truck, and with increasing costs of separating the asphalt from its host rock, the quarry closed in the early 1950s.

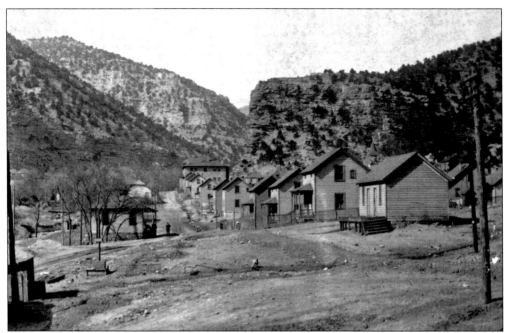

Named for its bright southern exposure, the coal camp at Sunnyside soon became a booming city. The first company homes were comfortable four-room wooden structures for the miners with families, and each ethnic group had their own boardinghouse for the single miners. Here are the homes in Whitmore Canyon near the mine site around 1910.

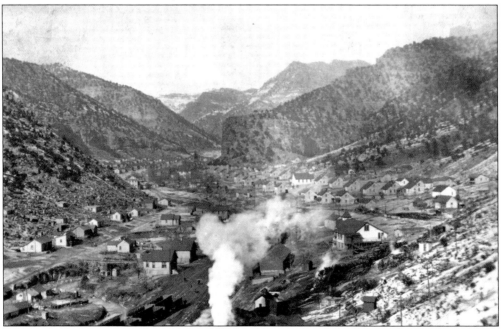

Sunnyside was incorporated in 1916, and Walter Wetzel was selected as the first town president. Sunnyside was booming—the town boasted two stores, a school, and its own hospital. By 1929, the town's population reached its peak at 2,000 residents. This image shows upper Sunnyside stretching into Whitmore Canyon. The company store is located on the right.

With Kaiser Steel Corporation taking over the mining operations at Sunnyside, the town experienced another building boom. In the early 1950s, Kaiser built new modern homes for their employees. The company also built new schools, a swimming pool, a golf course, parks and hiking trails, and baseball fields. This aerial view shows the new construction at Sunnyside and the neighboring town of Dragerton, now East Carbon, in the background.

Sunnyside experienced its own devastating mine explosion on May 9, 1945, with 23 miners losing their lives and dozens of others injured. The explosion occurred at 3:12 p.m. when methane gas in the mine ignited. Rescue crews from nearby mines rushed to assist in the operations. The Sunnyside Hospital, shown here in 1946, provided Sunnyside and the surrounding communities of Dragerton and Columbia with medical care with the aid of a company doctor.

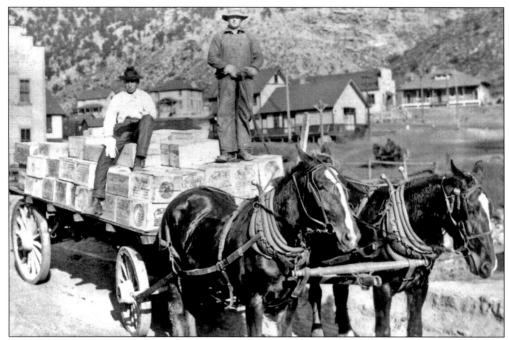

As Sunnyside's population grew, merchants and other service providers moved into town. Not only did Sunnyside have its required company store, identical in design to the company store in Sunnyside's sister camp of Clear Creek, but it also had Olivettos, a competing general merchandise store. Here a loaded wagon of canned food paused in front of Olivetto's rock storefront around 1910.

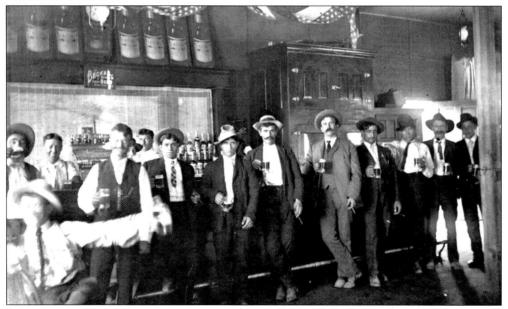

After the men returned to the surface at the end of their shift, the good times flowed at one of the Sunnyside saloons around 1918. The wide diversity of the ethnic groups of Sunnyside is evident in the faces of the patrons. Like most of the coal camps of eastern Utah, Sunnyside had a large population of Italian, Greek, Yugoslavian, and Hispanic immigrants.

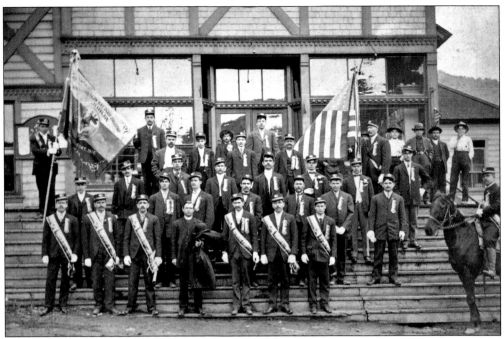

In an effort to maintain the culture and traditions of their home lands, immigrants to the area formed ethnicity-based organizations. The Slovenian Lodge in Sunnyside was one of the larger groups. Here the members pose for a photograph on the steps of the Sunnyside Company Store around 1910. The Slovenian Lodge had its own band that traveled throughout the county performing for special events.

One of the early problems with the town was the ability to get water. In 1906, water rights were purchased from ranching magnate Preston Nutter, and pumps powered by the mine's steam boilers were installed to get the water over the mountain into town. In addition to numerous other amenities, Sunnyside also boasted its own amusement hall, shown here (center) around 1920.

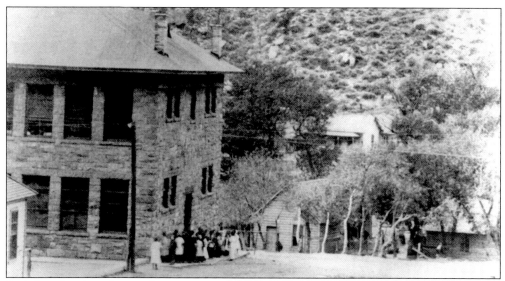

Built from local sandstone, the two-story Sunnyside school housed grades one through 10. Once students reached high school age, they traveled approximately 30 miles to Price, where they were housed in dormitories during the week. Eventually the Sunnyside and Dragerton area built its own high school. This image shows the school and its students around 1910.

During the 1930s, a trip to the company store was a great field trip. The students at Sunnyside posed for a photograph outside of the Wasatch Store Company in neighboring Sunnydale. Notice that many of the students have no shoes. The name Sunnydale was changed to Dragerton at the request of the U.S. Post Office because of its similarity to Sunnyside.

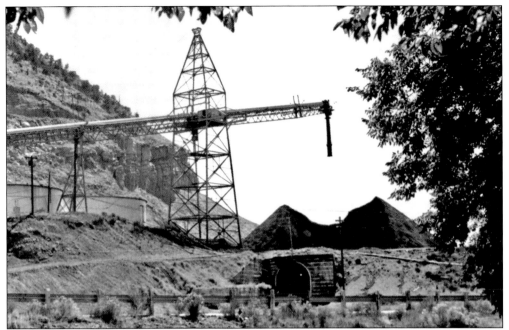

Located southeast of Sunnyside in the Book Cliff coalfield, the Columbia coal mine opened in 1923. Columbia was owned by the Columbia Steel Company and was later sold to U.S. Steel. In 1922, the company began its own railroad to transport the coal and coke to the main line of the Denver and Rio Grande Western Railroad. Named the Carbon County Railway, the line joined with the D&RGW at Dragerton.

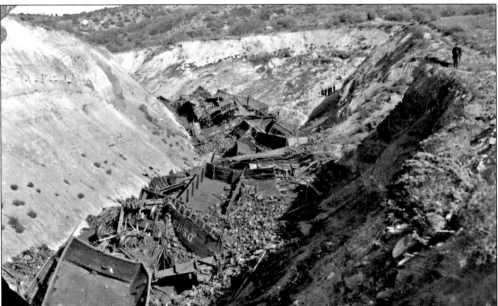

The Sunnyside area also saw its share of train wrecks. The steep grade leading out of Sunnyside was a challenge for railroad engineers. In 1930, a Denver and Rio Grande Western 3600 engine with a full load of coal lost control outside of Sunnyside and turned over at Columbia Junction where the Carbon County Railway joined with the D&RGW.

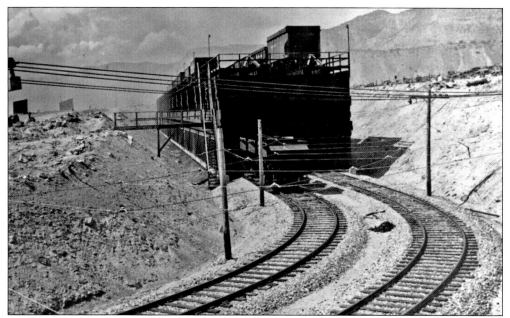

Columbia built and operated its own coke ovens, which were of a more modern design than the old beehive style and were more efficient. They are pictured here in 1955. Coke oven workers no longer had to shovel the coal and coke by hand. The Columbia Mine produced approximately 17.5 million tons of coal during its operation from 1923 through 1967.

The Columbia Mine closed in May 1967 because of poor working conditions in deep coal. The overburden reached over 3,000 feet. This image shows a roof collapse in the Columbia Mine around 1940. During the mining years, the Sunnyside, Columbia, and nearby Horse Canyon Mines removed nearly 40 million short tons of coal.

Seven

Lions, Warriors, and Four Mining Magnates

Located on the opposite side of Castle Valley from Sunnyside, the coal mining area near Hiawatha saw several coal mining communities from the early 1900s through the present day. The largest of these communities was Hiawatha, which eventually incorporated the towns of Black Hawk and East Hiawatha.

Mining in the area started in the late 1890s with a series of small wagon mines, so-called because of the method of transporting the coal from the mine. By the mid-1910s, the area surrounding Hiawatha was the largest producer of coal in the Wasatch Plateau coalfield.

Located north of Hiawatha, the town of Wattis began in 1917 when the Wattis brothers purchased 160 acres from the federal government and began to mine. By 1919, the company merged with Lion Coal Company and built a proper town with wooden homes, an amusement hall, and other community amenities. By 1965, the town was abandoned, although the mine still operated under the Plateau Mining Company until the late 1990s.

Just over the county line in Emery County south of Hiawatha, the town of Mohrland lasted only 28 years. The unusual name, pronounced Moreland, was derived by taking the first initial of the last names of each of the men who formed the Castle Valley Fuel Company: Mays, Orem, Heiner, and Rice.

The town of Hiawatha was the last town to close. Still in operation in the early 1990s, Hiawatha was closed and the last remaining residents moved into other areas of the county. A landmark of Hiawatha, a World War I Doughboy statue that stood watch over the center of town, was moved and rededicated in the Price Peace Garden on Main Street. Today the town of Hiawatha is in private ownership with the residents working to open the mines that were once so productive in the Wasatch Plateau coalfield.

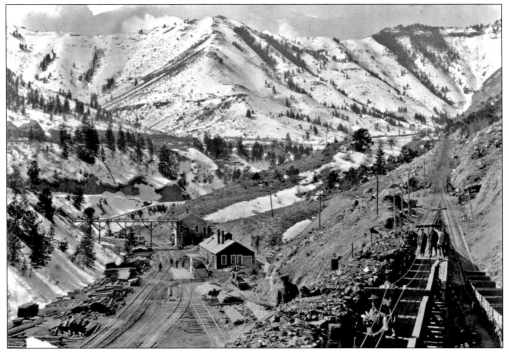

Founded in 1916 by W. H. Wattis, mining operations and the early town began in 1917. The town of Wattis sits at the foot of Gentry Mountain with Hoag Ridge, the highest point in Carbon County, as the backdrop. Here are the mine office and the railroad tracks in 1920. The tramway leading to the mine is shown on the right, and the town is on the hill to the left.

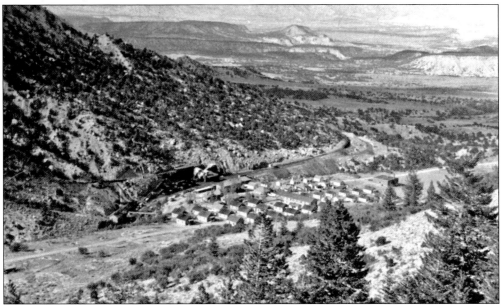

Located high on the flanks of the Wasatch Plateau, the coal camp of Wattis had a commanding view of the Castle Valley below. The mining operations at Wattis are visible at the center of this photograph taken around 1930. The mine cuts deep under the Star Point Ridge (left) and gives the mine its local name of Star Point.

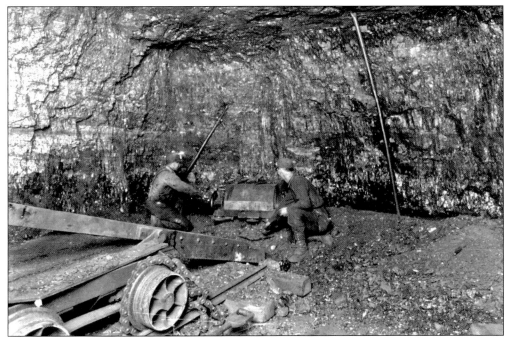

In 1919, the Wattis brothers sold the mining operations to the Lion Coal Company and the company began to build wooden homes for their employees. The coal seam averaged between 8 and 12 feet thick. This c. 1920 image shows two miners at the end of the previously mined area.

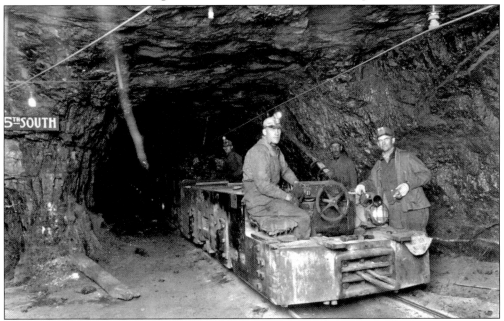

From 1917 to 1964, the Lion Coal Company mined approximately 7,784,150 tons of coal. In 1966, the mine was sold to Plateau Getty Oil Mining Company, who continued to mine the area until the mid-1990s. This c. 1920 image shows the small mine locomotive used to remove loaded coal cars. The sign at the left, like a standard street sign, tells the miners where they are underground.

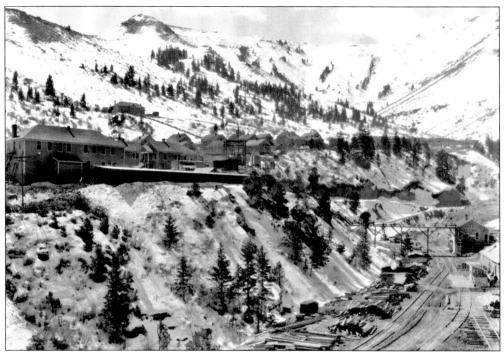
During World War II, coal was at its peak production and the town of Wattis flourished. The mine employed approximately 250 miners, and new homes and an apartment building were completed to house them and their families. This c. 1949 image shows the apartment building and the main part of town above the mine buildings.

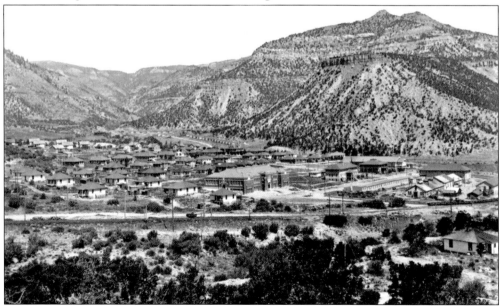
Identified by newspapers as the richest coal property in the west, Hiawatha was founded by the Consolidated Fuel Company in 1907. Coal mining began in earnest but slowed until a railroad line could be built to haul the coal. The camp of Hiawatha was not begun until 1911 and is shown here around 1925.

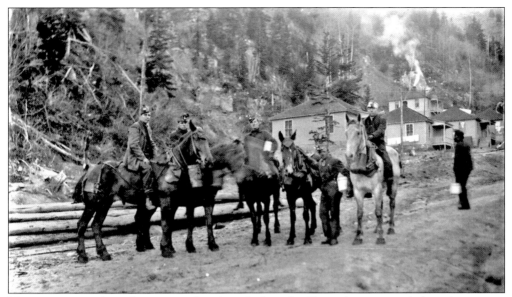

Numerous mines have been opened and worked in the Hiawatha area, including the mining operations in nearby Black Hawk east of Hiawatha. Early explorations date back to the 1870s, but large-scale operations did not begin until 1908. This photograph was taken on July 23, 1911, and shows the miners and their horses headed for the mine at Hiawatha. Miner John Krissman is pictured in the center of the image.

The largest mine to operate in the Hiawatha area was the King Mine, actually a group of mines operated at Hiawatha, Black Hawk, and Mohrland. Once the coal was removed from the mine, it was transported to the tipple where it was prepared for shipment. By-products of coal production called slag were removed from the tipple by horse-drawn wagon around 1915.

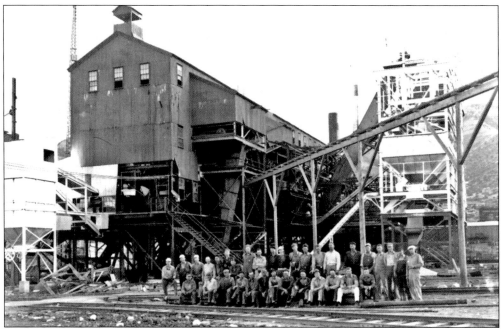

The Hiawatha tipple was always a hive of activity. The tipple was the building where the coal was deposited from the mine, sorted, cleaned, and then loaded into rail cars for transport. Coal is sold by size based on the customers' needs; the tipple sorted the coal into the appropriate size before shipping. This image shows the Hiawatha tipple crew around 1945.

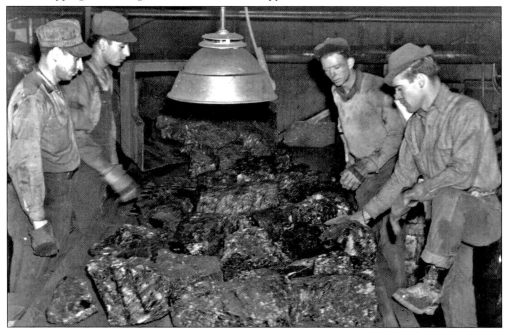

Inside the Hiawatha tipple, the picking tables were where any coal with rock attached was discarded. This coal was not acceptable for most customers. It was, however, sold at a discounted price to private homeowners. Here boney pickers (from left to right) Leo Falsone, George Falsone, Loren Lee Brooks, and Bill Needles are pictured around 1950.

The King mines in the Hiawatha area were the largest coal producers in the Wasatch Plateau coalfield. Between 1910 and 1969, the mines produced approximately 51 million tons of coal. This c. 1930 image shows miners at Hiawatha roof bolting. Roof bolts help to support the roof and help keep the mine from caving in. It is unclear why the miner on the right is standing in the dynamite box.

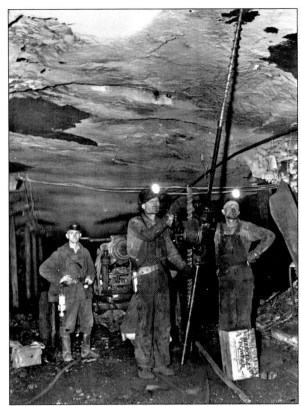

Used as a promotional piece, this large chunk of coal (below) was presented to the State of Utah by the U.S. Fuel Company. The coal was removed from the Black Hawk Mine in 1922. The lump measured 5-by-5-by-10 feet and weighed 20,900 pounds. An 8-ton block of coal from Hiawatha was sent to the Panama Exposition in San Francisco in 1915.

Southwest of Hiawatha was the town of Black Hawk. By 1911, the area originally called Hiawatha was called East Hiawatha. In 1915, the two towns consolidated and the area officially adopted the name of Hiawatha. Here is the Hiawatha Meat Market around 1912 just as Hiawatha's business district was getting started.

U.S. Fuel Company provided the residents of Hiawatha with many amenities. The town had an amusement hall, a library, a school, two churches, and even its own dairy. Located just outside of town, the Millerton Dairy, shown here around 1920, provided the nearby camps with fresh milk, cheese, and cream.

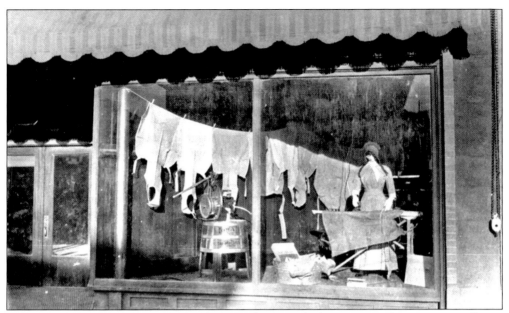

Hiawatha's business district was every shopper's dream in the late 1910s, with many stores offering a wide variety of goods. The Hiawatha Mercantile was on the cutting edge of homemaking technology, advertising the latest in washing machines and irons. Displays like this one made the idea of doing daily chores in a coal camp much more bearable.

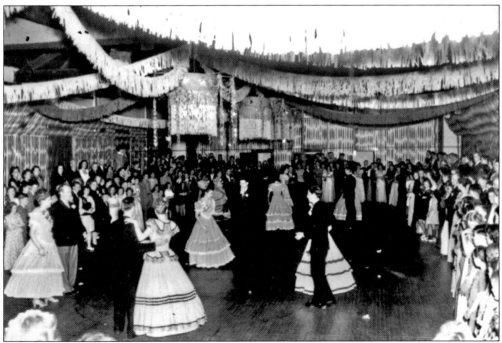

One of the most popular activities in the coal camps was dancing. Hiawatha's amusement hall provided plenty of space for dances as well as a banquet room. This photograph shows a Gold and Green Ball on October 7, 1949. Gold and Green Balls were events sponsored by the Church of Jesus Christ of Latter-day Saints Mutual Association.

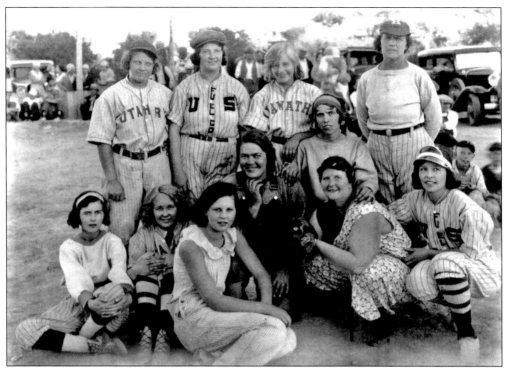

Not only did the U.S. Fuel Company organize baseball teams at each of their camps, but they also organized women's teams. These women's games attracted as many spectators as their male counterparts. The ball teams traveled by train to games throughout the county. This image shows the U.S. Fuel Company Hiawatha women's ball team around 1938.

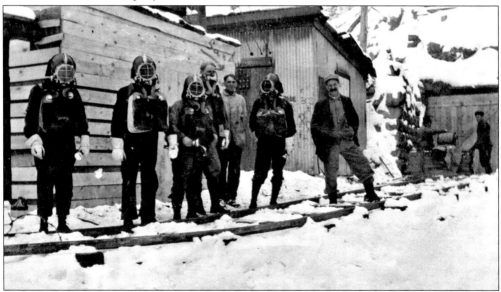

In October 1913, the mine at Black Hawk caught on fire. Rescue crews donned safety equipment and cleared everyone from the mine. The fire continued to burn until mid-1915. Mining operations resumed, and like other U.S. Fuel Company properties, the mines claimed a 90 to 96 percent coal recovery rate.

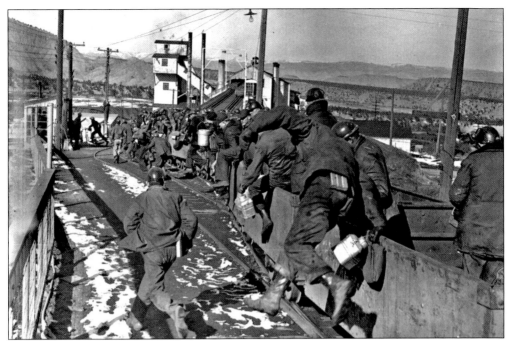

Mining waned in the mid-1940s, but the town of Hiawatha hung on. However, as automobile travel became more and more common, people moved away from Hiawatha and commuted to work. By the early 1990s, only a handful of families lived in the town. This c. 1950 photograph shows the miners rushing for the bathhouse after their shift.

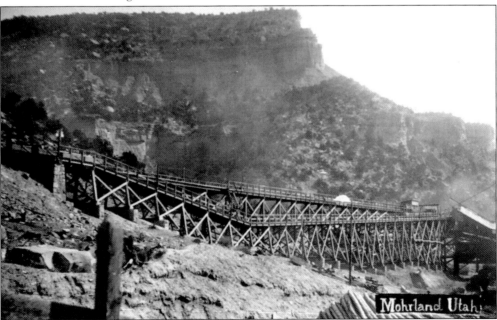

Located just over the Carbon County line in Emery County, the town of Mohrland was named for the owners of the Castle Valley Fuel Company: Mays, Orem, Heiner, and Rice. Although coal deposits had been mined in the area since 1896, the large-scale mining operations began in 1910. Here is the graceful tramway at the Mohrland mine around 1911.

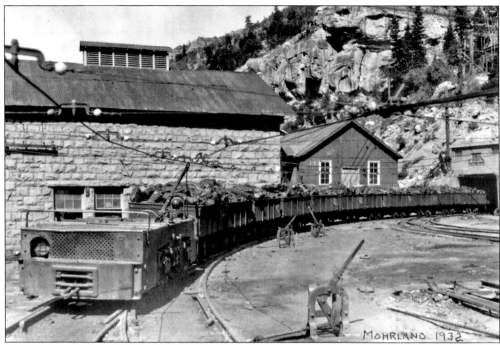

Brothers William and Erin Howard opened a mine in the Cedar Creek Canyon area in 1906 and operated a successful mine in the 17-foot coal seam, using horses and wagons to remove the coal. Here loaded coal cars leave the King Mine No. 2 in 1932, a short six years before the mine closed for good. (Courtesy SueAnn Martell.)

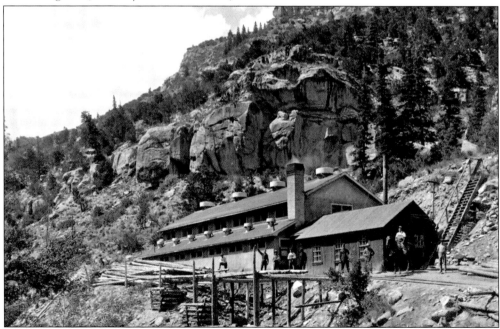

The King Mine No. 2 at Mohrland was a modern mine and offered many amenities to the miners and their families. The town had a school, an amusement hall, and its own company hospital. Pictured here is the bath and change house at the entrance to the mine around 1915.

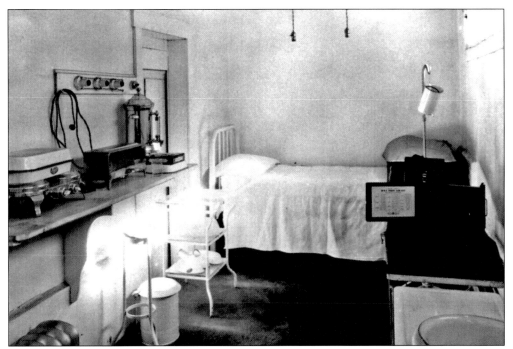

Mohrland had its own company first-aid station inside the bathhouse, shown here around 1915. Each miner paid a monthly fee, which entitled him and his family to the services of the company doctor. Not just reserved for health care, the monthly fee also provided the families with entertainment in the form of movies and dances.

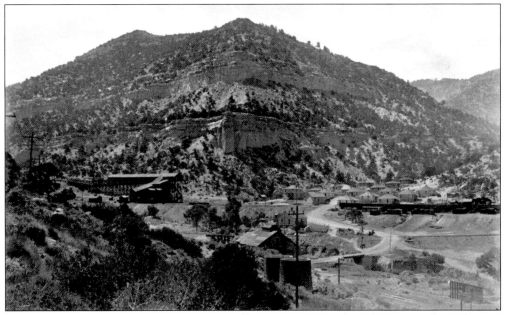

Mohrland was spread out over separate small communities within the town. These districts were Centerville or Brotherhood Flat, Gobblers Knob, Tipple Town, and Japanese Town. This photograph shows the main part of Tipple Town, so named because of its location next to the tipple. The Utah Railway yard is seen at the right of the photograph.

The town had its own boardinghouse for single miners and travelers. This postcard (above) was sent from Mohrland to Hiawatha to Mr. and Mrs. Steckelman by their daughters, who had vacationed in Mohrland on August 24, 1916. The girls assured their parents that they had enjoyed themselves and would be bringing home elderberries.

Mohrland had a rich sense of community pride that showed in everything they did. The town had a hotel with a beautiful fish pond, shown here with Sue Moshie around 1924. In addition to a wide range of recreational activities, Mohrland had its own seven-piece orchestra that played for dances in both Emery and Carbon Counties.

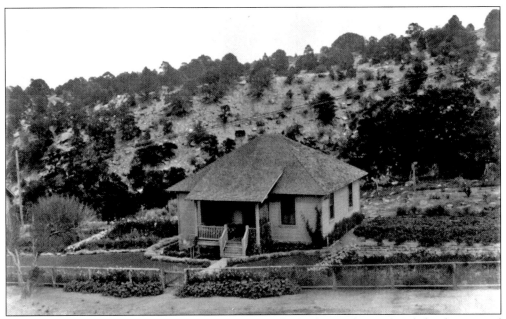

Although the soil was rocky and the coal dust was thick, the residents of Mohrland competed fiercely with each other during the annual U.S. Fuel Company Lawn, Flower, and Garden Contest. This photograph shows the winning yard for 1930 surrounding the home of R. M. Kelly, whose garden was voted the most attractive flower garden.

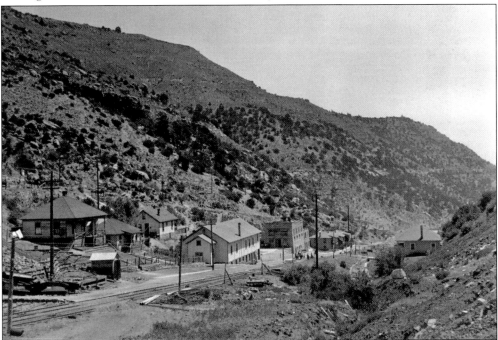

Unfortunately, the town of Mohrland was in existence a short 28 years before the mine was closed for good and the residents moved away. The first indication of the town's demise occurred in 1925, when the mine closed for one year. This photograph shows the center part of Mohrland, including the company store and the amusement hall (center).

Discover Thousands of Local History Books
Featuring Millions of Vintage Images

Arcadia Publishing, the leading local history publisher in the United States, is committed to making history accessible and meaningful through publishing books that celebrate and preserve the heritage of America's people and places.

Find more books like this at
www.arcadiapublishing.com

Search for your hometown history, your old stomping grounds, and even your favorite sports team.

Consistent with our mission to preserve history on a local level, this book was printed in South Carolina on American-made paper and manufactured entirely in the United States. Products carrying the accredited Forest Stewardship Council (FSC) label are printed on 100 percent FSC-certified paper.